Keys to Painting
Buildings & Barns

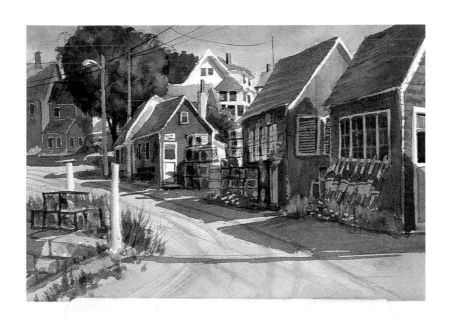

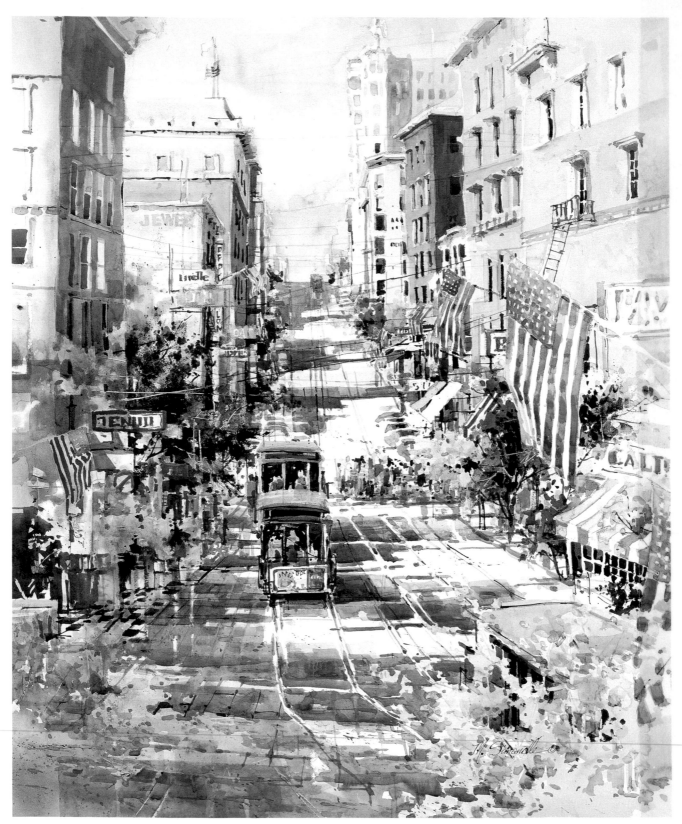

MARILYN SIMANDLE
Cable Connections
Watercolor, 40"×30" (102cm×76cm)

Keys to Painting
Buildings
& Barns

EDITED BY RACHEL RUBIN WOLF

NORTH LIGHT BOOKS
CINCINNATI, OHIO

The material in this compilation appeared in the following previously published North Light Books and appears here by permission of the authors. (The initial page numbers given refer to pages in the original work; page numbers in parentheses refer to pages in this book.)

Bye, Ranulph. *Painting Buildings in Watercolor* ©1994. Pages 122 (5), 42-49 (16-23), 58-59 (24-25), 24-25 (54-55), 106-111 (56-61), 80-83 (62-65), 22-23 (66-67), 16-21 (68-73).

Hill, Tom. *Painting Watercolors on Location with Tom Hill* ©1996. Pages 8 (9), 62-77 (82-97).

Kaiser, R.K. *Painting Outdoor Scenes in Watercolor* ©1993. Pages 34-37 (10-13), 26-31 (26-31).

Maltzman, Stanley. *Drawing Nature* ©1995. Pages 40-41 (14-15), 94-97 (50-53).

Nice, Claudia. *Creating Textures in Pen and Ink with Watercolor* ©1995. Pages 58-61 (74-77), 78-81 (78-81).

Rocco, Michael P. *Painting Realistic Watercolor Textures* ©1996. Pages 96-97 (102-103), 116-117 (104-105).

Simandle, Marilyn. *Capturing Light in Watercolor* ©1997. Pages 37 (2), 32-33 (32-33), 38-47 (34-43), 50-55 (44-49).

Strisik, Paul. *Capturing Light in Oils* ©1995. Pages 118-119 (118-119), 92-95 (120-123), 112-115 (124-126).

Wagner, Judi and Tony Van Hasselt. *Painting with the White of Your Paper* ©1994. Pages 112-113 (98-99), 90-91 (100-101).

Wolf, Rachel Rubin. *The Acrylic Painter's Book of Styles and Techniques* ©1997. Pages 98-109 (106-117).

Other fine North Light Books are available from your local bookstore, art supply store or direct from the publisher.

03 02 01 00 99 5 4 3 2 1

Library of Congress Cataloging-in-Publication Data

Keys to painting: buildings & barns / edited by Rachel Rubin Wolf.—1st ed.
 p. cm.
Includes index.
ISBN 0-89134-977-4 (pbk.: alk. paper)
1. Buildings in art. 2. Barns in art. 3. Art—Technique. I. Rubin Wolf, Rachel
N8217.B85K49 1999
751.42'244—dc21 98-44344
 CIP

Editor: Rachel Rubin Wolf
Content editor: Karen Spector
Production editor: Christine K. Doyle
Production coordinator: Erin Boggs
Cover designers: Brian Roeth and Tim Kron

ACKNOWLEDGMENTS

The people who deserve special thanks, and without whom this book would not
have been possible, are the artists and authors whose work appears in this book.
They are:

Ranulph Bye Stanley Maltzman Paul Strisik
Tony Couch Michael Nevin Judy Wagner and Tony Van Hasselt
Tom Hill Claudia Nice Rachel Rubin Wolf
R.K. Kaiser Michael P. Rocco
George Kountoupis Marilyn Simandle

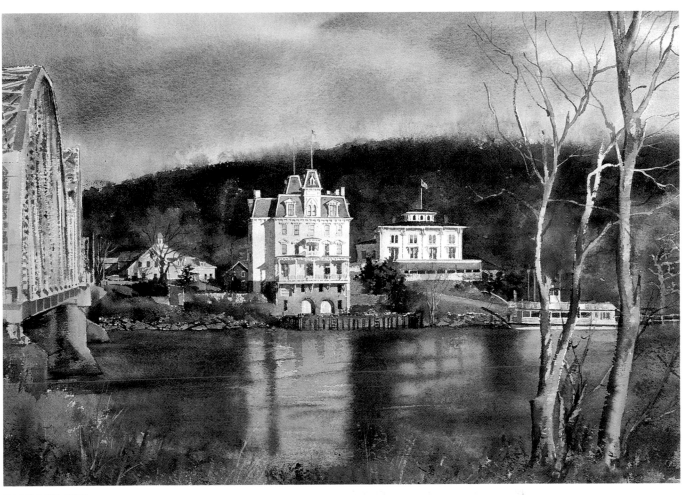

RANULPH BYE
Goodspeed Opera House, East Haddam, Connecticut
Watercolor, 22″ × 30″ (56cm × 76cm)
Collection of American Artists Group, Inc., New York

TABLE OF CONTENTS

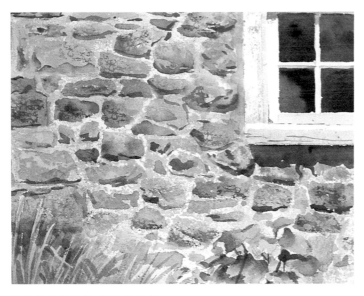

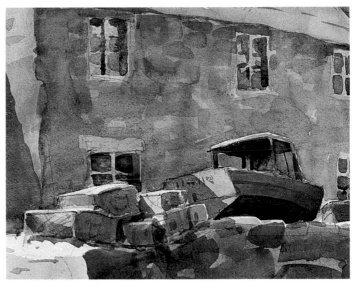

CHAPTER THREE
Creating Building Textures

CHAPTER FOUR
Demonstrations in Watercolor, Acrylic and Oils

INTRODUCTION

Lowly root cellars, dilapidated barns, stately homes, cozy villages and street scenes from exotic locations all have one thing in common to you the artist. They represent the challenge of capturing what attracted you to the subject in the first place. It could have been the sunlight or shadows; it could have been interesting architectural elements like mansard towers or gables; it could have been a feeling you had while viewing the subject, extraordinary composition, fascinating color combinations or unusual textures. Whatever brought you to artistically appraise the building in front of you, your goal now is to capture it. This book will help you in that endeavor.

You will find on the pages that follow a great deal of practical and insightful instruction for painting buildings and barns. You will learn a wealth of information on how to paint textures like stonework, brick and old wood. You will see great artists at work from initial sketch to finished painting. George Kountoupis and Tony Couch will show you how to use the white of your paper. Michael Nevin will show you how to use multiple thin washes to add character to your painting. Paul Strisik will teach you his methods for handling light and shadow. Undoubtedly, the most valuable result to come from reading this book will be embracing techniques from other artists, modifying them to fit your own needs, and then adding them to your artistic repertoire. We hope you will do just that.

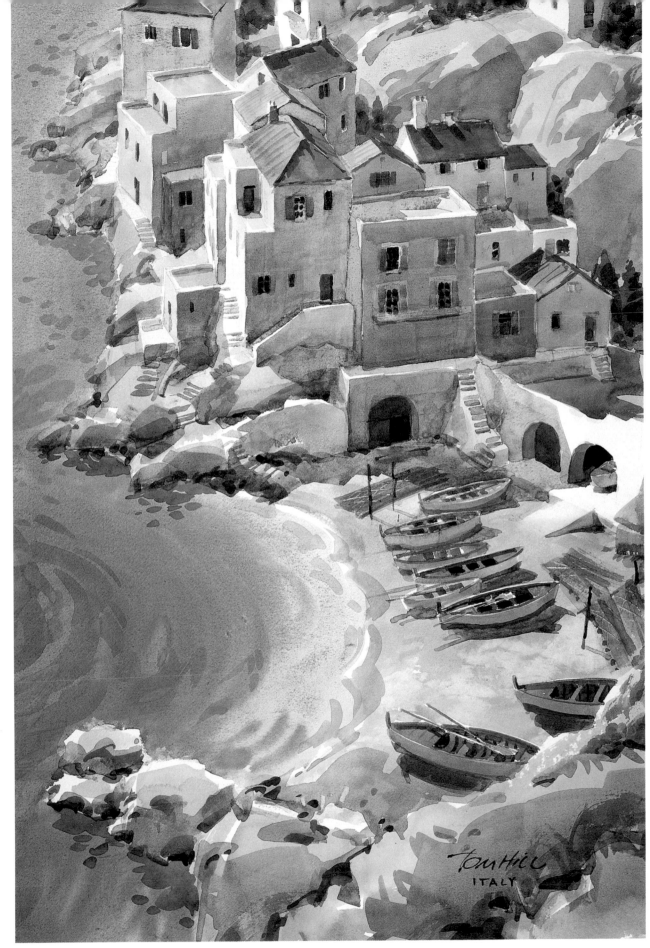

TOM HILL
Along the Amalfi Coast, Watercolor, 21" × 14" (53cm × 36cm)

Drawing and Perspective

Drawing

The preliminary black-and-white sketch is an important building block for planning your painting. "When you fail to plan, you plan to fail," as Tony van Hasselt often says. You *must* plan before you start your watercolor.

Let's say you've arrived at the scene and decided from what angle you want to paint. Now is the time to take out your sketchbook and pencils or markers and sketch in values and shapes. Capture the sunlight on the subject and its cast shadow or, if it's a gray day, balance the light and dark tones. Explore the composition in front of you.

As you sketch, move things around, erase them and change them: Do anything you can to make it better. Sketching like this gets your creative juices flowing. Sketch any way you like—fast, detailed, loose, tight, dark or light—whichever way will help you plan your painting. Depending on the scene in front of you, you may do a contour drawing or a quick sketch that picks up just the major points, or, if you have time, a more detailed drawing.

CONTOUR DRAWING

Contour drawing is one of the quickest and most personal ways to put line on paper. Just put your pencil on the paper and move it around. Don't lift it off the paper. Keep it moving while you look at the subject in front of you and then look back to the paper. Think of your pencil as actually touching the objects in the scene. If things overlap, fine. Keeping a very simple outline of the subject will provide you with the "pure" look of the subject. However, its very simplicity makes it quite difficult. In contour drawing, you attach the subject to the background shapes. Suggest forms and shapes—don't draw every bush, rock or tree—leaving empty spaces within the lines of your drawing.

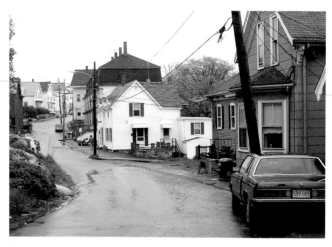

A contour drawing is the best way to capture the rhythmic motion of the winding road and overlapping houses in this scene.

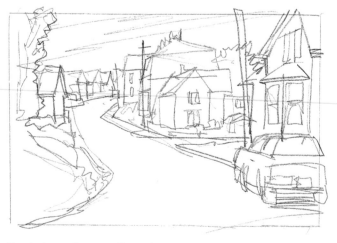

Try to keep the pencil moving in a simple, rhythmic way along the outlines of the road and houses.

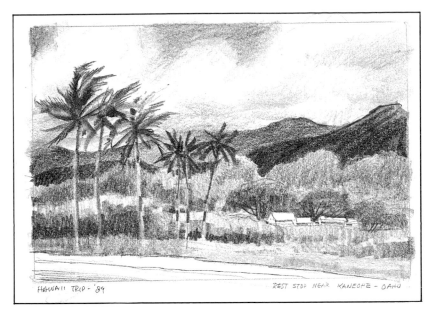

This Hawaiian scene was sketched from a rest stop along a road in Oahu. Although the sketch is quite simple, it shows a lot of the area.

On a trip through Holland the artist did some sketches from the bus, working quickly to capture the light, shadows, values and large shapes.

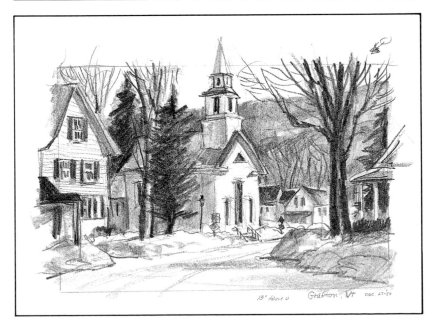

The picturesque town of Grafton, Vermont, is a great place to paint. The artist parked on the side of the road and used his car hood for a table, sketching very quickly— it was about 13° F.

Sketches by R.K. Kaiser

QUICK SKETCHES

Quick sketches are the best way to draw when doing outdoor painting. Because the sun is constantly moving, you don't have time to capture much more than the direction of the sun, the subject and the cast shadows. Just get the details you need for the painting—the most important aspects of the scene in front of you. Concentrate on the direction of the light, the major shapes and values and the cast shadows, as the artist did in the three sketches on the previous page.

DETAIL DRAWINGS

These are not exactly the opposite of quick sketches, but they're a way to remind yourself of the local character or flavor of a scene. Local character includes the variety of details that adds interest to the scene or subject—the big oil drum on its side, the pile of lumber, the small "For Rent" sign on the side of the building, the crumbling stucco, the iron railing, cobblestones, a leaning broom on the porch, a shovel in the barn or a hanging harness—little things that make up the mood or feeling, the time or place of the scene in front of you. You can do a detailed drawing and then later, at your convenience, leave out what you don't think will give you the flavor you want. Jot down some notes in your sketchbook, or even in the border of your sketch, because when you walk away from the scene, you may never get back to it. Make notes of the colors of objects you draw to jog your memory later.

OUTDOOR VS. INDOOR DRAWING

When sketching outdoors, you have to be aware of time. The sun and the shadows move constantly. You have to sketch as quickly as possible but still get as many of the particulars as you can to capture the flavor or mood of the scene. Leaving the scene without at least a quick sketch and trying to paint it from memory in your studio later (unless you have a photographic memory) just won't do. You'll forget many important parts of the scene or the subject.

On the other hand, indoor drawing—where the light is constant, the temperature is under your control, and there are no bugs or disrupting factors—is ideal for a lot of people and is the only way they want to work.

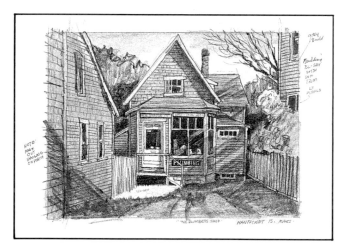

(left)
This plumber's shop is one of the great houses on Nantucket Island, with interesting shapes and shadow patterns. The sketch includes enough architectural detail to allow an accurate rendering in watercolor.

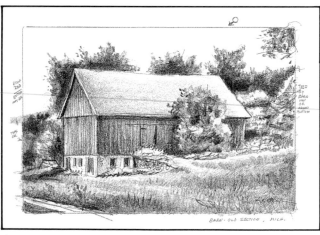

(above)
There are barns in every state, some more interesting than others. This barn is simple, but it was surrounded by beautiful fall colors. The artist jotted down notes in the margin to help him remember the colors later.

(above)
This crabman's shack on Chesapeake Bay had so many interesting things around it that the artist put everything in. He'll simplify it considerably when he does the watercolor, choosing the details he likes best.

However, you can't truly capture the feeling of a landscape working only in your studio—unless, perhaps, you have many years of on-location painting experience. But you can compromise. Sketch outdoors, and then bring your sketches home to your studio or work area. In the convenience of home you can move that tree, shift that barn, overlap a couple of boats, enlarge that boulder or widen that small part of the stream. Remember, you're the artist: You decide what you want to do and what to put before your viewing public. The painting is the final product of your artistic ability.

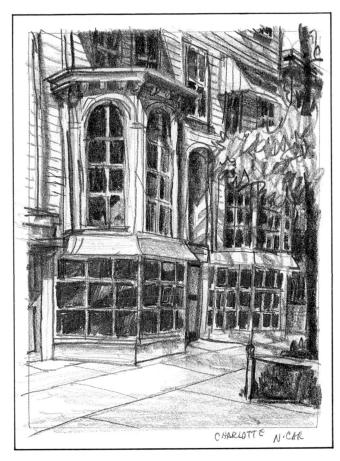

Sketching outdoors and using his car hood as an easel, the artist tried to capture the intricate shadow pattern on this old building.

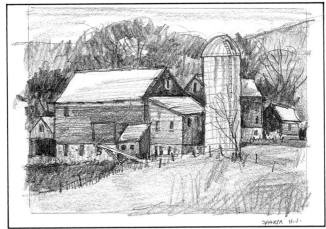

The artist did this sketch during a painting workshop in Sparta, New Jersey. The lighting on this interesting complex of barns and buildings was diffused on that gray, threatening day.

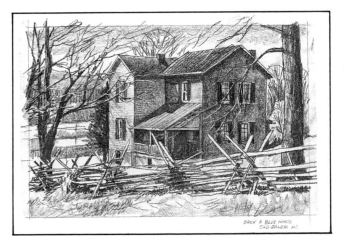

The artist did this pencil sketch in his studio from reference photos. This house in Old Salem, North Carolina, was a great subject. Of course, the fence made it doubly interesting.

Sketches by R.K. Kaiser

Perspective

SIMPLE PERSPECTIVE

Using perspective in landscape drawing can be perplexing and challenging, but perspective is one of those important elements of picture-making that makes your picture believable. Here, we will talk about simple one- and two-point perspective.

Where your eye meets the horizon is called the *eye level* or *horizon line*. That imaginary line is a straight, horizontal line. The horizon line will naturally change as you lower or elevate your viewpoint. If you elevate your viewpoint, you will be looking down at the horizon line. This is called *above eye level* or *bird's-eye view*. If you are below the horizon line, it's called *below eye level* or *worm's-eye view*. The horizon line or eye level, once established, does not change: There can be only one horizon line in any one picture.

Somewhere along that horizon line is the *vanishing point*, an imaginary point where parallel lines eventually meet. When you look at railroad tracks, you notice that the tracks seem to converge at one point in the distance. That is the vanishing point. Sketches *A*, *B* and *C* illustrate this simple one-point perspective.

In two-point perspective, two sets of parallel lines go to two vanishing points (see the diagram on the next page). This is important to remember when you are including buildings in your landscape, because not every barn or house will be situated with its front plane parallel to your view or picture plane, as in one-point perspective.

One-Point Perspective

In the diagram at right, all parallel lines at an angle to the frontal plane converge to one point—*VP*—the vanishing point. The bench and open box are below eye level, so you see inside the box and the top of the bench. If they were moved closer to the VP, you would see less of the inside of the box and less of the bench seat.

Drawing *B* shows a plowed field. Like railroad tracks, the furrows recede to one point along the horizon line, which is the vanishing point.

In drawing *C*, a meandering stream diminishes in width as it reaches the horizon line, and disappears into a field or valley beyond. That point on the horizon line is the VP.

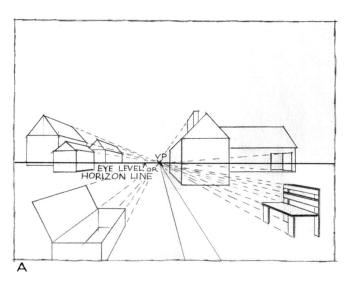

A

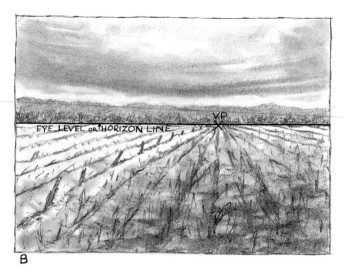

B

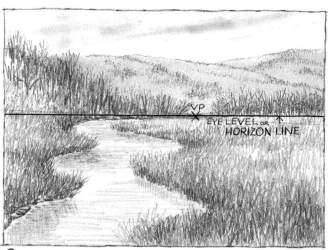

C

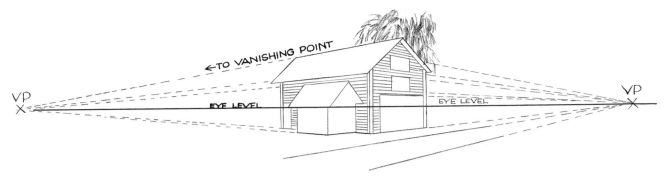

Two-Point Perspective

Because the old barn and shed are situated at an angle to the artist's viewpoint, the front and side of each building have their own vanishing points. That means all parallel lines on each plane converge to their own vanishing point, one to the right and one to the left, as shown in the diagram.

Once you decide on your horizon line, or eye level, and your vanishing points, everything else—roof angles, clapboard, windows and doors—will all fall into place. For a better understanding, lay a piece of tracing paper over the finished drawing below and trace the lines to their respective vanishing points.

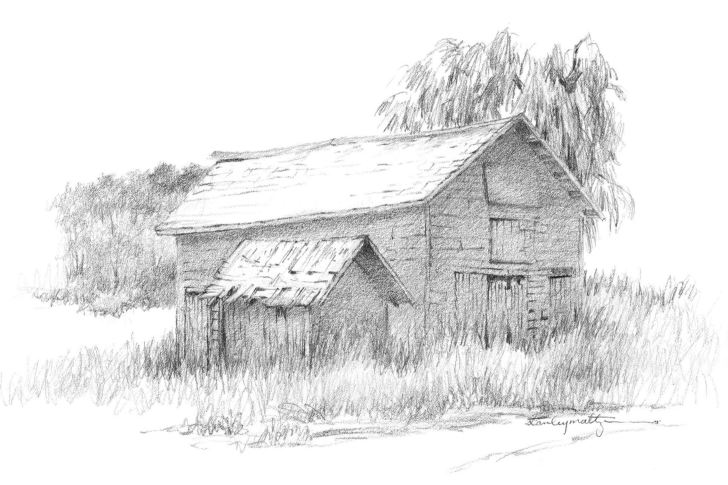

STANLEY MALTZMAN
Road Side
Graphite pencil, 11"×14" (28cm×36cm)

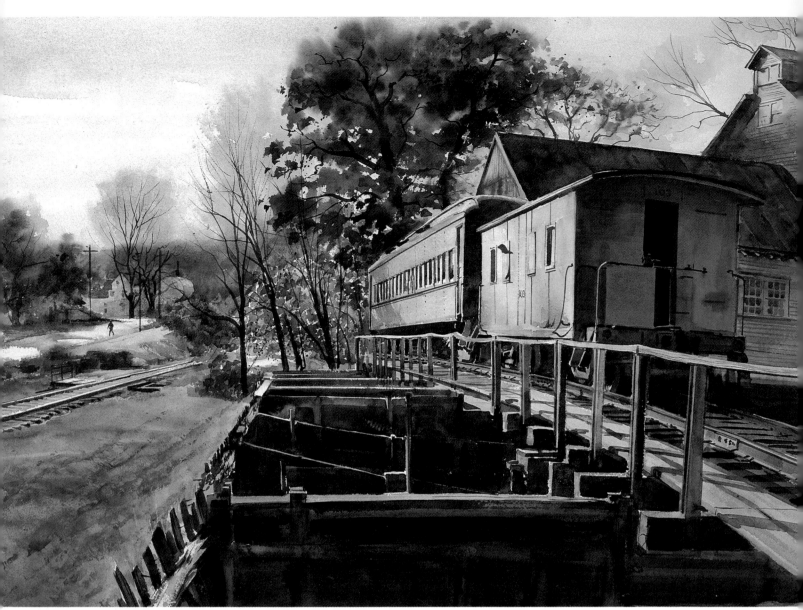

PERSPECTIVE AND ARCHITECTURE

When you encounter a subject with buildings, you most certainly will have to get the perspective right. This means making the elements of your picture—the street, houses, windows, rooflines, figures and so on—recede into space in the right proportion.

The basis of perspective is the vanishing point. All parallel lines of building will appear to converge on this point and on the horizon line, which is at the eye level of the artist. This means that no matter where you are standing, the horizon line also coincides with your eye level.

Here's an example of one-point perspective, where all parallel lines appear to converge on a vanishing point. The walkway on the right not only leads the eye into the composition, but also points the way to the vanishing point in the distance.

These coal bins were once used by a local lumber, coal and feed dealer to store coal for distribution in the local community. The demise of the need for coal means the siding becomes a temporary parking spot for a railroad car and caboose.

The sharp autumn light offered a chance to play up a strong value contrast of the cars against the coal bins and the mill behind.

RANULPH BYE
Wycombe Coal Bins, Wycombe, Pennsylvania
Watercolor, 21" × 29" (53cm × 74cm)
Collection of Lambertville Station

This diagram of the painting below shows one-point perspective of the covered bridge and ground line. Notice that your eye level coincides with the horizon line.

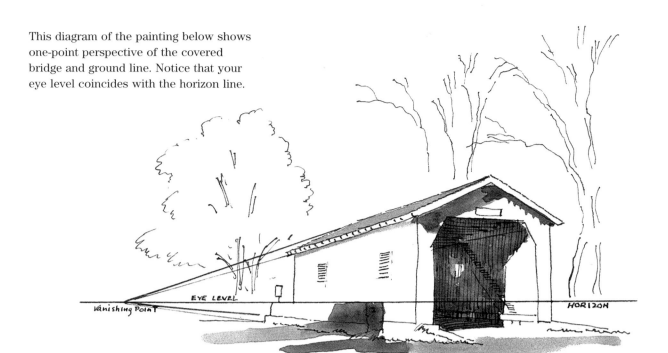

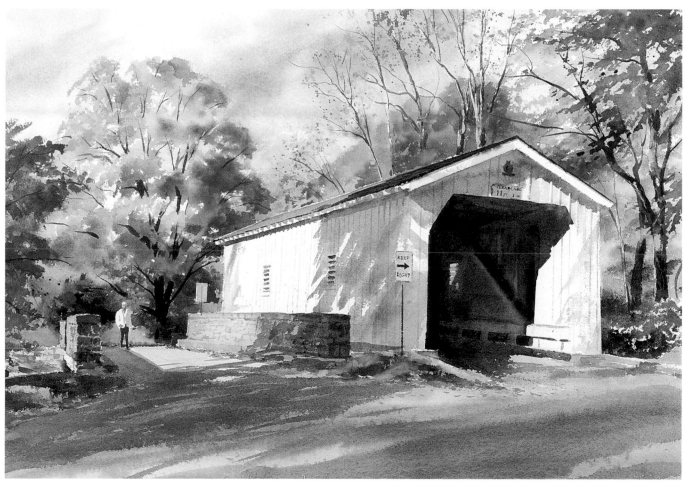

RANULPH BYE
Green Sergeant's Bridge
Watercolor, 21"×29" (53cm×74cm)

The only extant authentic covered bridge in New Jersey was built in 1750 and rebuilt a hundred years later. This watercolor was painted over a period of two days in a beautiful fall setting. The long autumn shadows in front and on the bridge are exciting. The strong dark interior against the white created an eye-catching center of interest.

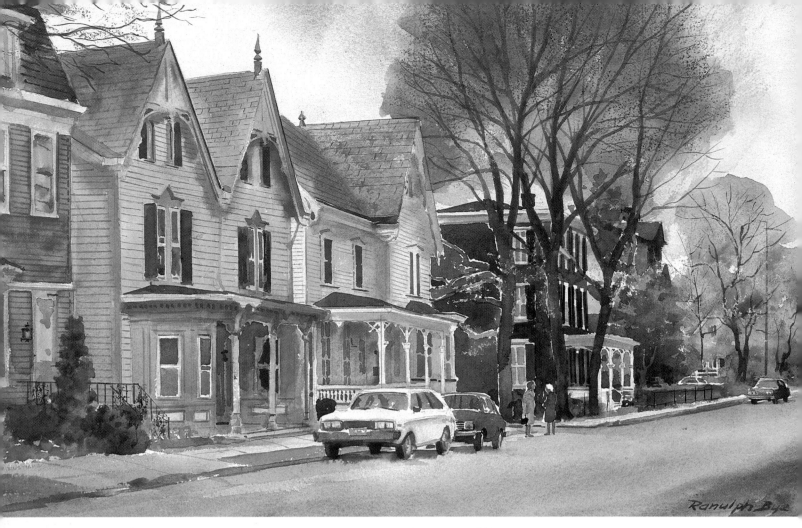

One-point perspective is very evident here. The curb of the street and the horizontal lines of the houses converge to a vanishing point just beyond the car in the distance. Eye level runs through the rooftops of the two cars and the heads of the standing figures.

A common error in street scenes is that the street angle runs uphill too sharply instead of lying level with the ground. Always check this line with the horizon line.

RANULPH BYE
Gables and Porches, Lambertville, New Jersey
Watercolor, 15"×21" (38cm×53cm)

For example, look at the schematic of the William Penn Center (right, top). Notice how the rooflines and baselines converge to vanishing points to both the right and the left somewhere outside the picture plane on the horizon line, but the vertical lines remain vertical.

Sometimes groups of buildings are not parallel to each other. They will then have their own separate vanishing points. On the other hand, when drawing a house from a front elevation or dead center, there is no perspective to worry about; all lines are either vertical or horizontal.

To get the angle of a line running sharply away, hold up your pencil on the line, see what angle it makes with the vertical and bring the pencil down immediately onto the paper, looking up again to check. Be aware that ground lines below your eye level go *up* to the right or left; lines above eye level go *down* to the right or left. In the course of time and with experience, drawing buildings in correct perspective comes without much difficulty. (For a more in-depth guide to using perspective, see *Perspective Without Pain* by Phil Metzger, North Light Books, 1992.)

After laying out the building in proper perspective, you can then draw in where the windows, doors and chimneys go. Some houses contain a lot of detail, such as corner brackets, cornices and shutters, and these will have to be considered before you start to paint. If cars and figures appear in your painting, get them in right away before they move, or allow placement for them. Also, note where lights and shadows occur; these change during the course of a day.

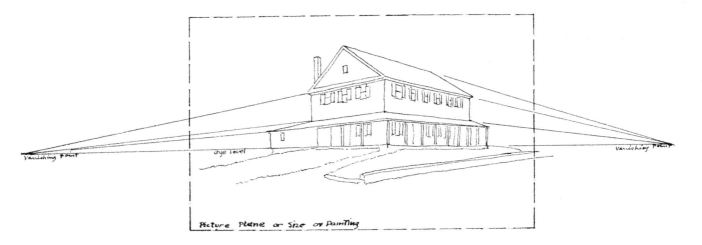

This diagram shows two vanishing points, to the right and to the left of the meeting house. Note that eye level is on a line with the base of the building.

RANULPH BYE
William Penn Center, Falls Meeting, Fallsing-
ton, Pennsylvania
Watercolor, 16" × 24" (41cm × 61cm)

A fine example of a Friends meeting house of stone construction built in 1787. The artist painted this watercolor on location after having drawn it from a slide earlier. He chose a winter setting because it provided the most favorable opportunity to view the building with the least amount of foliage obstruction. The morning light gave him the best chance to capture the angled light on the end gable, and the tree shadows in the foreground help set back the building in a dignified manner.

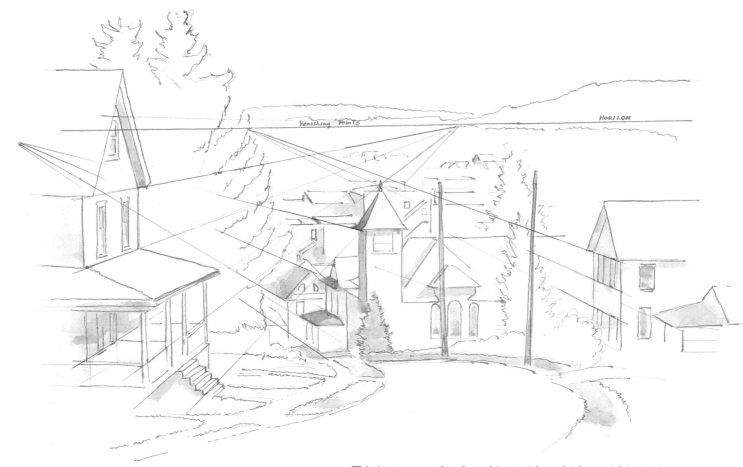

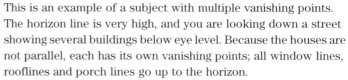

This is an example of a subject with multiple vanishing points. The horizon line is very high, and you are looking down a street showing several buildings below eye level. Because the houses are not parallel, each has its own vanishing points; all window lines, rooflines and porch lines go up to the horizon.

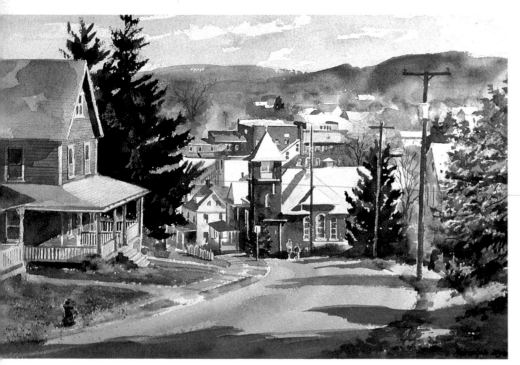

RANULPH BYE
Village Street in Montgomery, Pennsylvania
Watercolor, 14½" × 21" (37cm × 53cm)

Here is the finished painting based on the above sketch. Because the horizon line is high, the view of the street is from above, and the tops of the buildings are visible.

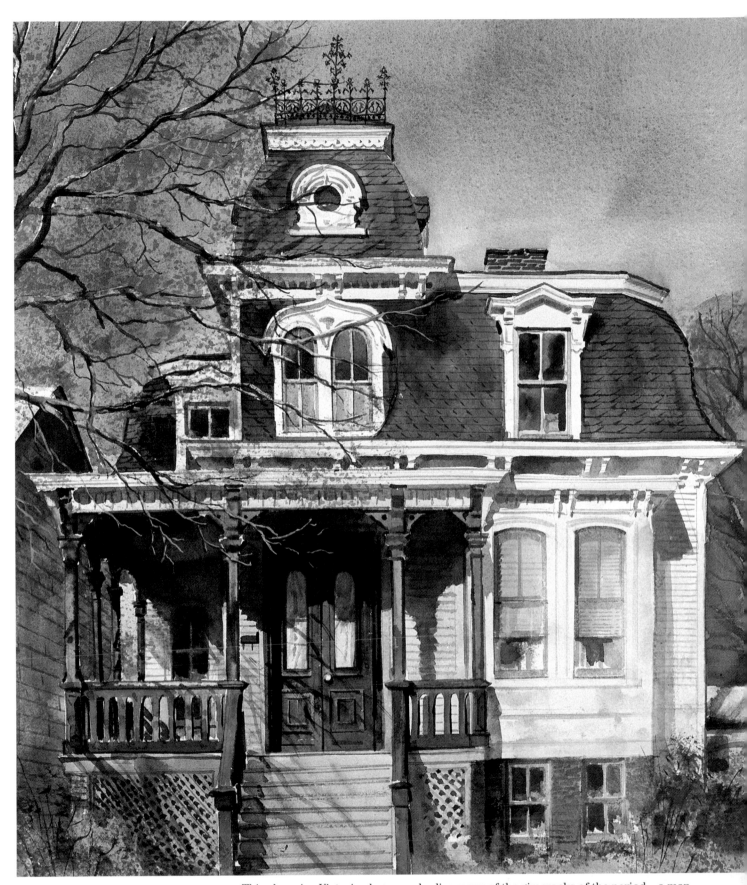

RANULPH BYE
Victorian House, Middletown, New York
Watercolor, 20"×16" (51cm×41cm)

This charming Victorian house embodies many of the gimcracks of the period—a mansard tower with porthole dormers, iron roof cresting, paired windows, veranda-like porch and tall first-floor windows. This watercolor was painted from a dead-center position, and no perspective was evident on the horizontal.

Common Errors

Whether painting on location or indoors, a number of common errors are made in drawing and perspective. These errors mainly have to do with placement of the subject matter, achieving balance without boring symmetry, being careful with perspective, avoiding placing the center of interest in dead center and drawing objects in correct proportion.

On these pages you will see a number of the most common problems, as well as suggestions for solutions to those problems.

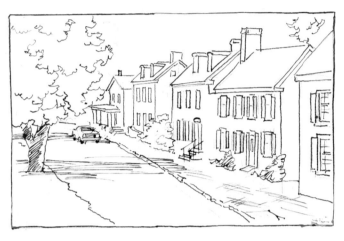

PROBLEM: A row of houses in a small town showing a street rising much too sharply. The street has no perspective.

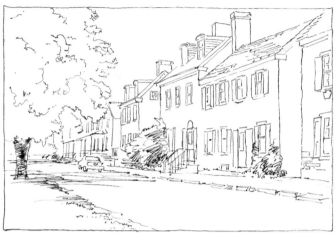

SOLUTION: The same street showing the curb, windows and rooflines receding to a vanishing point on the horizon running about one-third of the way up the picture.

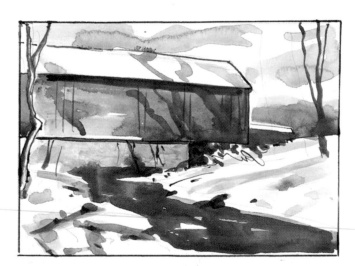

PROBLEM: Covered bridge crossing a creek—a fine motif but badly conceived. The tree hugging the side of the painting on the extreme left is awkward.

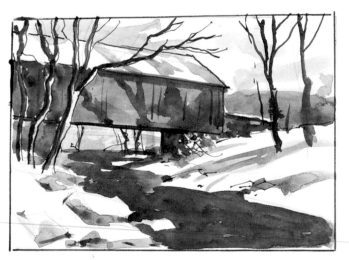

SOLUTION: Bringing in more trees creates better balance both to the left and to the right.

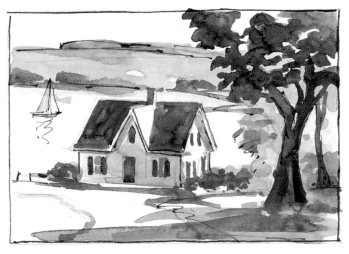

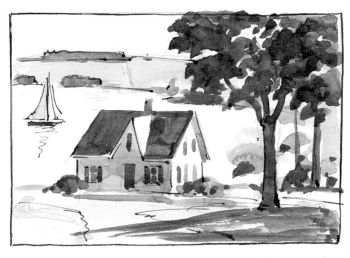

PROBLEM: The tree trunk on the right is much too wide at the bottom.

SOLUTION: Tree trunks are columnar in shape and flair out only a few inches above the ground line.

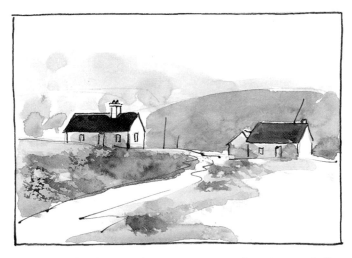

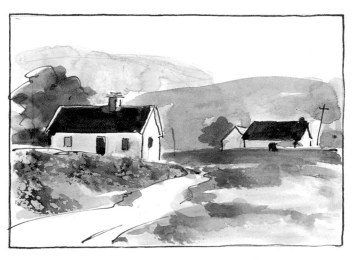

PROBLEM: The houses along a country road are too much the same size and placed equally distant from the sides of the picture. Such a composition creates a hole in the middle.

SOLUTION: Bringing the house on the left into the foreground makes a better balance with the house in the back: balance without symmetry.

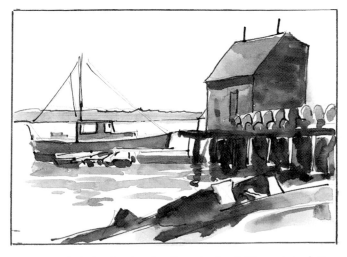

PROBLEM: Lobster boat unloading at wharf. The point where the bow of boat meets the end of wharf is too close, causing an eye pocket. Also, the point where the roof of the cabin coincides with the distant shoreline shows bad placement.

SOLUTION: The boat has been moved further away from the dock, and the distant shoreline has been lowered below the cabin roofline, improving the composition.

Composition and Color Harmony

Composition Variations

Aperfect composition just waiting to be copied exactly as you see it is seldom found in nature. Something will have to be simplified or taken out of the scene, and shapes must be arranged so there is balance. A big mass can be balanced with a small mass. A composition should always have pleasing abstract qualities, even if it is not pure abstraction. Forget the subject matter at first. Are the shapes big and small, cool and warm, dark and light? Always think these things out before you develop your painting into a series of recognizable objects.

When starting a watercolor, look for an interesting pattern or an exciting feeling of light on a building. Old houses, barns and streetscapes with vintage architecture show character and age. You'll want to capture the mood these subjects suggest. Often the arrangement of shapes you create will set the mood for the painting. The following examples show various ways to compose a painting with a building as the center of interest.

RANULPH BYE
Thatched Cottage
Watercolor, 9½″ × 12″ (24cm × 30cm)

The painting above and "Willows, Clinton" at right use a similar compositional plan. In each the building is the center of interest, though it is not the largest thing in the picture. Two main principles are used to focus attention on the building in each case. First, both the cottage and the church are located at one of the key points on the Golden Section. The Golden Section is the best place to establish a center of interest—a spot located 38 percent vertically or horizontally vs. 62 percent vertically or horizontally. Second, the two buildings are light (or white) objects surrounded by dark to midtone elements. The highlighted left side of the cottage and the church steeple are the brightest objects in the paintings.

(right)
RANULPH BYE
Willows, Clinton
Watercolor, 9½″ × 12″ (24cm × 30cm)

RANULPH BYE
Porch and Goldenrod
Watercolor, 19"×28" (48cm×71cm)

The paintings above and at the right use a very different composition plan from the ones at left and below. Here we are up so close that we see only a portion of the building, and that portion takes up almost the whole picture frame. In each case, one large rectangular shape (one horizontal, one vertical) dominates the picture, and that sheer dominance becomes the center of interest. Look carefully, though, and you'll see that the Golden Section is not forgotten. The lower right corner of the white porch and the round turret of the Victorian building both sit smack on one of the key points of the Golden Section.

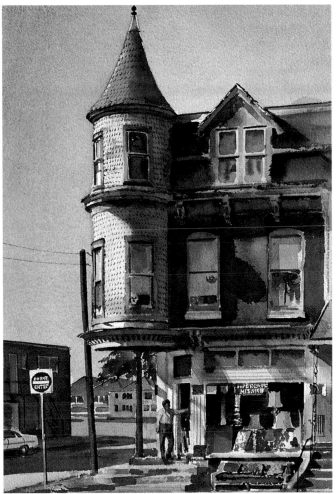

RANULPH BYE
Halloween Corner
Watercolor, 14½"×21" (37cm×53cm)

Arranging Shapes

What is good composition? It is the harmonious arrangement of shapes in a painting, so that each area is in correct proportion and has a pleasing variety of color, value and texture. The artist organizes the parts of a work to achieve a unified whole.

There are many ways to arrange shapes in a painting. Arrangement is based on a number of things, including the subject itself and the mood you want to convey. Shape is the strongest single element. As Edgar Whitney often said, "We are shapemakers."

VARIETY IS MORE INTERESTING

We often fall into "traps": painting mountains the same height, spacing trees evenly like fence posts or making all the rocks the same size. Varying the height and apparent size of trees, buildings or other objects will prevent boring repetition and generate much more visual excitement in your painting. Also, throwing things a little off-balance makes any painting more interesting. That little touch will make a viewer really stop and look.

POSITIVE SHAPES

Barns, houses, major trees, rocks and boats—all of these are subjects we love to emphasize. These are usually your points of interest, the things you want everybody to look at, the things you want to stand out. These are called *positive* shapes.

The variety of pleasing points of interest can include areas of light or dark. To be dominant, one will usually have to be larger than the other. Keeping the tonal value of your positive shapes simple will make them stand out too.

These mountains are all the same height—and very boring.

Just a small variation in height makes them much more interesting.

When all the trees are the same size, the image is boring and does not make a good composition.

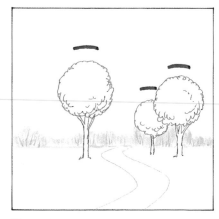

Here, size variation and overlapping make a big improvement.

R.K. KAISER
Miklous Farm, Illinois
Watercolor

Here are three small watercolor sketches by R.K. Kaiser. In this first one, the irregular half-circle of the top of the barn is an obvious positive shape, as is the light blue parallelogram of the roof. The inverted orange triangle of leaves between the roof and silo is a negative shape.

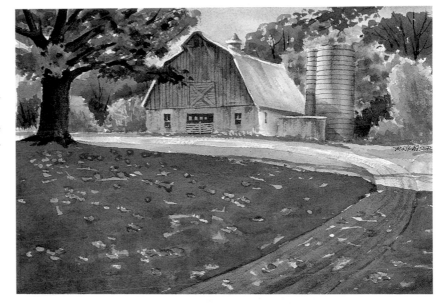

Here is a light area silhouetted against a dark. The white farm buildings are a positive shape; the dark trees form a negative shape behind them.

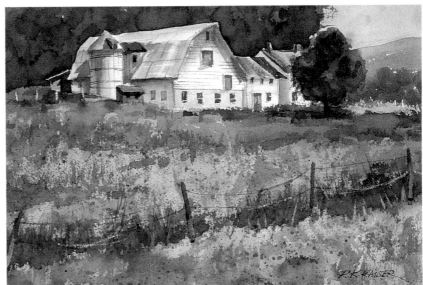

This silo dominates the picture, commanding attention. The big shapes are broken up a little by the stones and shadow pattern, and by the mountains and shrubs to the right.

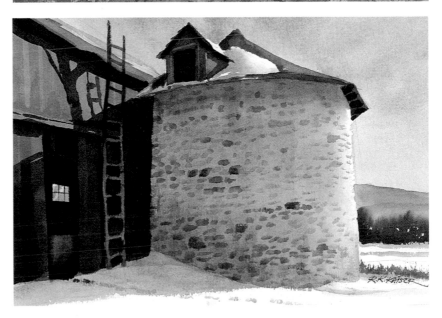

NEGATIVE SPACES

Negative shapes include air, sky, water, trees, maybe even sand or grass—anything that makes up the space around the positive shapes. Areas of dark or light can be either negative or positive, depending on how they are used. If one area has a dark or gray background, an adjacent area that is left white will stand out and be a posi-tive shape—for instance, a white barn against dark green trees. But if a large area is left white, it usually becomes a negative shape.

OVERLAPPING

Overlapping is one of the easiest ways to produce a better painting. Overlap-ping objects (buildings, rocks, trees or whatever) instead of scattering them all over your painting instantly organizes them and makes them more inter-esting. Overlapping can tie a whole scene together or shift a picture left to right, up and down. It can show per-spective, and always helps to define the relative size or height of objects in a scene. Above all, it's the best way to avoid making a boring painting.

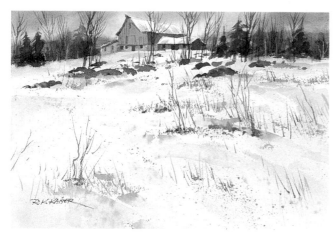

A big negative area of snow is set off by a dark area of positive shapes at the top. The high horizon line makes this scene interesting even though three-quarters of the painting is negative space.

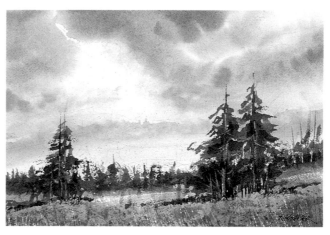

This is just the opposite of the negative snow scene. The horizon line is much lower, with the darkest area at the bottom offset by the light sky.

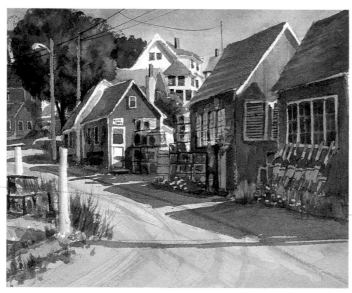

In this scene of Gloucester, Massachusetts, the overlapped lobster shacks and trees and the small details of local color help show perspective and distance.

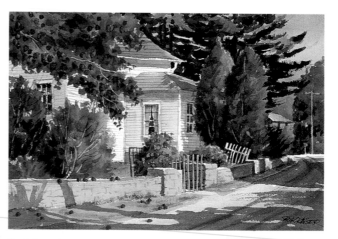

In this painting, the trees that overlap each other and the house, plus the building in the distance around the curve, all combine to create a sense of depth.

SILHOUETTES

In arranging shapes for a painting, be aware of the silhouette shapes that stand out in the scene and help define the forms of the objects. As "shape-makers," we must keep our shapes simple. Breaking the edge of a silhouette can be interesting, as long as it doesn't make the shape confusing. If you break the silhouette too much you may lose it completely. Silhouettes are a great help in composition: They make your painting instantly understandable.

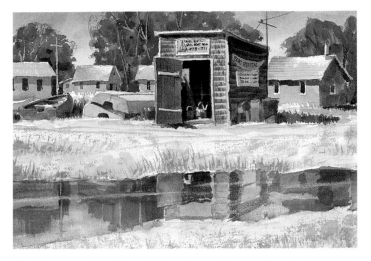

The boat rental building, the boats and the buildings in the background, though modeled with color, are silhouetted against the dark trees. The silhouette shapes help to show the forms of the boats and buildings in the background. The telephone pole and tree outline describe what the shapes are. Notice how the darks in the background outline the buildings, chimneys and roofs to clarify what we are looking at.

The lighthouse and the trees are silhouetted against the light sky—dark against light—making a clear, dramatic reading of form.

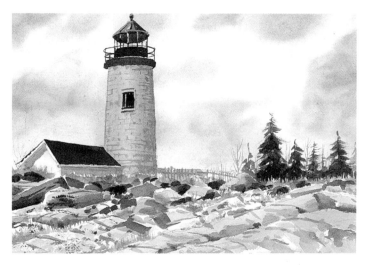

Again, light shapes are silhouetted against dark backgrounds. Simple trees in the background outline the stalks and fences. The artist darkened the barn to show off the middle wheat stalks.

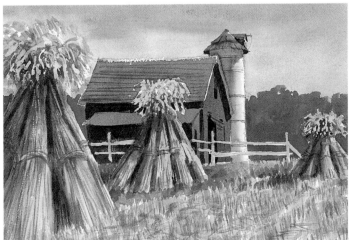

Paintings by R.K. Kaiser

VIGNETTES

Vignettes are one of the simplest ways to solve problems with a scene. Let's face it; sometimes it's difficult to get interested in a scene. You might do a preliminary black-and-white value sketch, or small pencil sketch, and find it still doesn't seem to gel. A vignette—a picture with an irregular shape without square edges to frame it—just might be the solution.

Although you won't cover the entire painting surface, you should touch all sides of your painting with color. But counterbalance the edges you touch. In other words, don't touch two sides directly opposite each other. Use areas of white to allow the viewer to enter into the scene, but don't leave so much white space that it becomes overpowering and too important. On the other hand, too little white space will destroy the vignette shape.

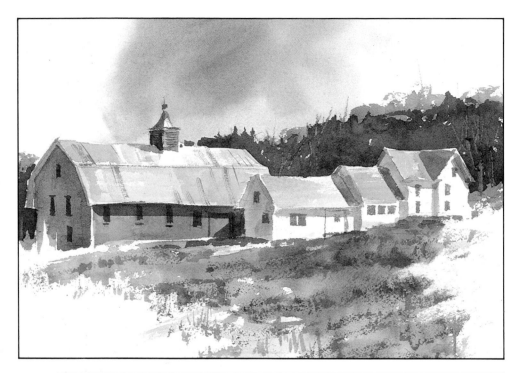

In vignettes, it's important for objects to touch the sides of the paper, but not directly opposite each other. Notice how the blue sky area is touching the top edge a little left of where the green ground mass touches the bottom edge. The green trees on the left touch the edge just about midway; the trees on the right are slightly higher. The whites of the background form a pattern of different shapes. A white area leads in from the left and directs your eye toward the houses.

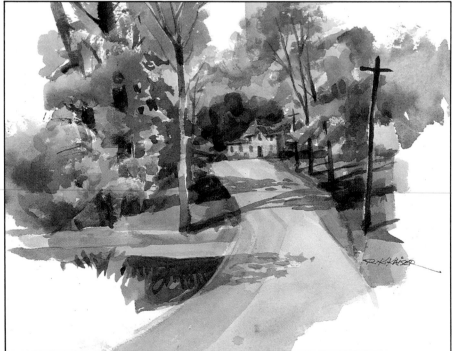

This vignette, though horizontal, has a vertical thrust. The artist used a drybrush technique to produce sharper edges, which made the white area more apparent.

Paintings by R.K. Kaiser

ENTRANCES AND EXITS

When you stop to look at a painting, how do you view it? First of all, the fact that you've stopped means the painting has caught your attention. Now, can you enter the painting, walk around in it and come out visually satisfied? It sounds strange, but think about it. If, when viewing a painting, you have to fight your way through visual barriers to get to the point of interest, the painting's composition has been poorly planned. Visual barriers can be a big hindrance to the enjoyment of any painting. The composition should have "entrances" and "exits" that allow you to get into the painting, explore it and then get out. Vertical lines, such as fences, trees and so on, placed on the sides or in the foreground stop your eye. You can't visually jump the barrier to get at the point of interest. By breaking these lines, you create an entrance into the middle of the painting, allowing viewers to gain access to what you intended for them to see. By the same token, your composition should let them explore and then give them a way out of the scene—an exit.

This scene in Vermont is quite a simple painting, but well thought out. Your first inclination would probably be to enter the scene from the dirt road at bottom center and travel immediately up to the white church. But you can also enter the scene visually from points 1 and 6 at the left. Points 2 and 3 let you explore the center of the painting. Points 7, 8 and 9 let you roam around some more. You can exit the scene at the right from points 4 to 10 or from 9 to 10.

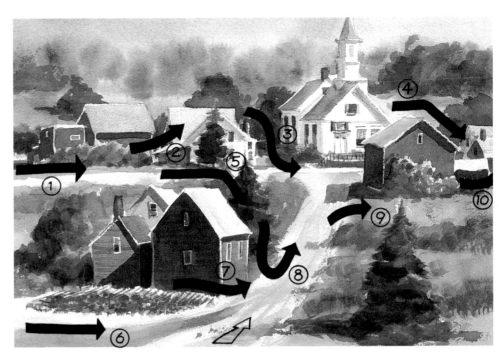

Again, you would likely enter this scene first from the snow-covered area in front of the barn. But this snow scene can also be entered from points 1 and 3—point 1 coming in from the hill curving to point 2 and encompassing the barn, and then on to point 6, and then up the hill and out, or out through point 7. Another entrance is from point 4, moving along to where the barn roof breaks the mountains at point 5, and then on to points 6 and 7.

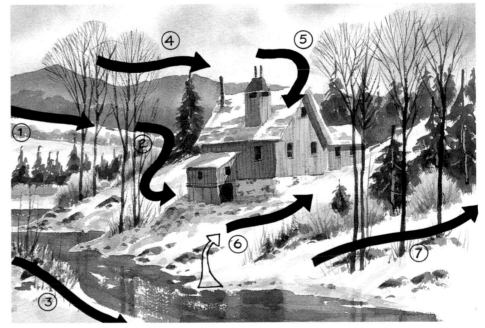

Creating Eye Movement

An Interesting Scene
The placement of shapes can create harmony through eye movement. Should you try to capture every detail in this photo? Good luck! Not every weed, shingle and railing is necessary. It's the light, the mood and the overall look that you want to capture.

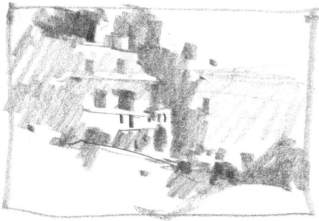

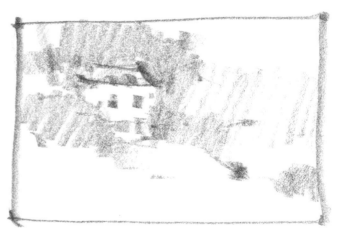

Basic Shapes
Start simplifying by reducing this subject to its basic shapes as you sketch the scene. Leave out smaller, unimportant, duplicated shapes that don't enhance the effect you're trying to achieve. What you're really doing is distilling the scene to its basic elements. Now you can experiment with placement of elements, free from all that burdensome detail. Compare these sketches to the photo to see how much has been left out. Not only will it be much easier to paint, but the finished painting will be stronger than one painstakingly copied from a photo.

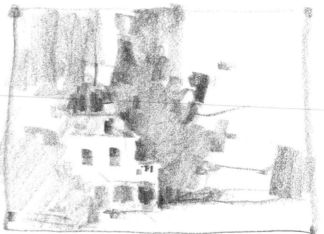

MOVEMENT IN MODERATION

Lines and edges are so powerful at moving the viewer's eye that you will usually have to moderate them by introducing little bends, breaks and turns, especially in vertical elements, to stop the eye from moving too quickly.

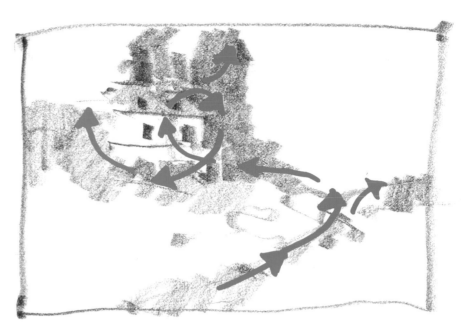

Eye Movement

To show eye movement, arrows have been added to the final sketch. Note how the eye enters at the foreground and moves up the triangular road shape toward the middle ground. The eye continues around the curve of the road to arrive at the point of interest, the house. It continues to the background and up into the trees. There's no detail in this sketch—just shapes.

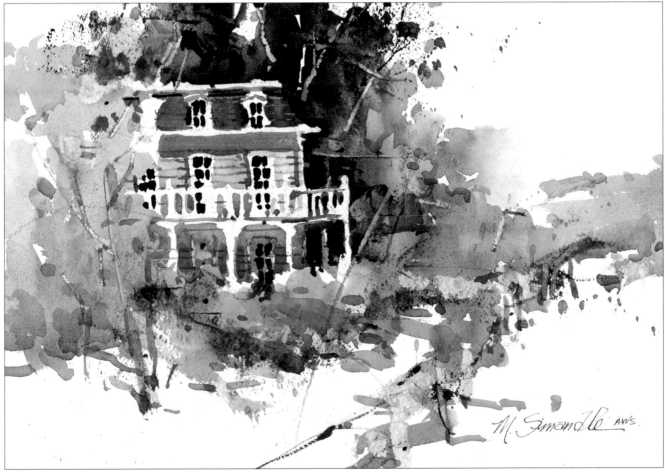

MARILYN SIMANDLE
Virginia City
Watercolor, 9" × 12" (23cm × 30cm)

Color Harmony

Harmony in art is no different from harmony in life. Elements in a painting, like people, are in a harmonious relationship with each other when they have things in common, when they agree and when they feel comfortable with each other.

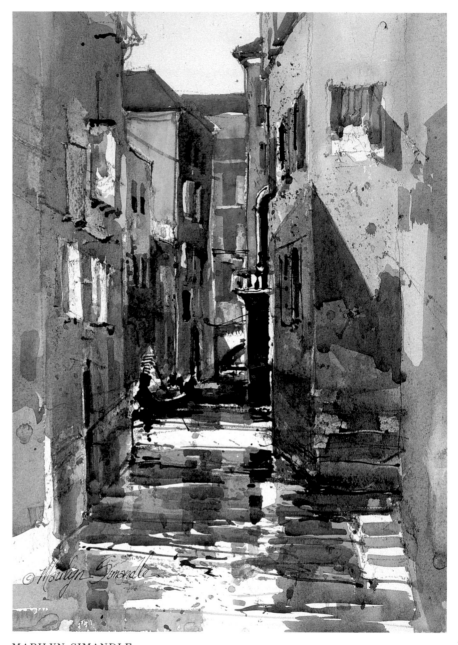

Pleasing Visual Harmonies

This painting's visual appeal is enhanced by the pleasing harmonies present in it. The dominant hues are yellow (Burnt Sienna, Raw Sienna), orange (Cadmium Orange), pink (Permanent Rose) and red (Cadmium Scarlet). These are analogous colors, which adjoin each other around the color wheel. The eye moves easily from one to the next because they are similar, as are the predominant values, which also enable the eye to move easily among them (there is greater contrast in the center of interest). The related nature of the repetitive and similar shapes in this painting invites the eye to move among them easily as well, without encountering abrupt changes.

MARILYN SIMANDLE
Venice Canal
Watercolor, 16" × 12" (41cm × 30cm)

Analogous Colors Harmonize

Analogous colors adjoin each other around the color wheel.

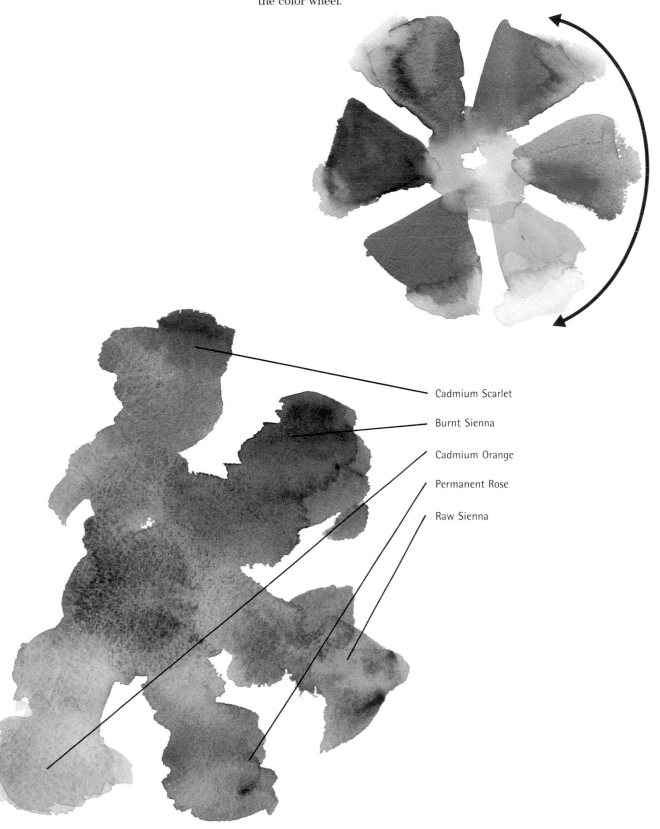

Cadmium Scarlet

Burnt Sienna

Cadmium Orange

Permanent Rose

Raw Sienna

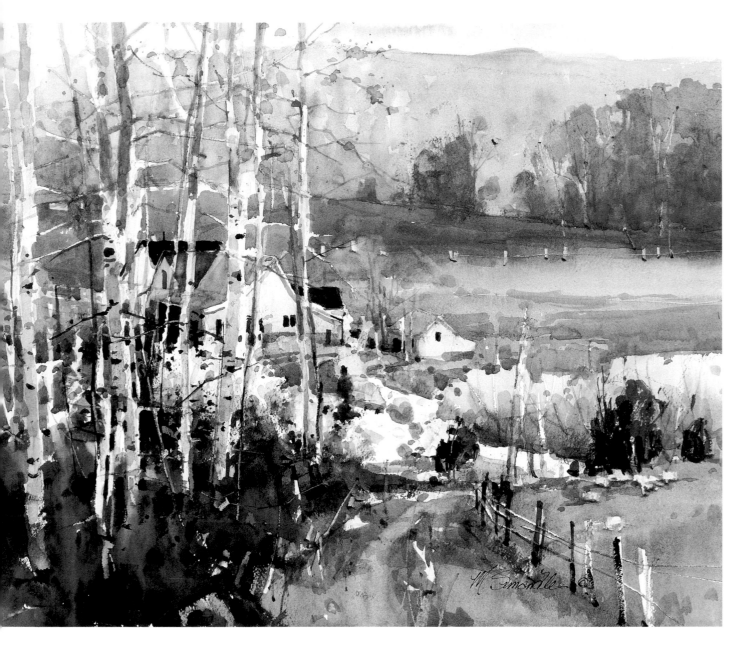

FIND HARMONIOUS COLOR RELATIONSHIPS

Harmonious colors in the world around us give us pleasure: the warm brilliance of autumn foliage, the pastel shades of a sunrise, the infinite greens of a forest and the fading hues of mountains layered to the horizon.

MARILYN SIMANDLE
Country Twilight
Watercolor, 16" × 20" (41cm × 51cm)

Color, Value and Line Harmonies

An analogous palette of violets, blues and greens, in similar values, dominates this painting for a harmonious effect. The treatment of the linear elements—painted with a fine brush, scratched in and using lost-and-found edges—keeps repeating tree shapes related and yet interesting.

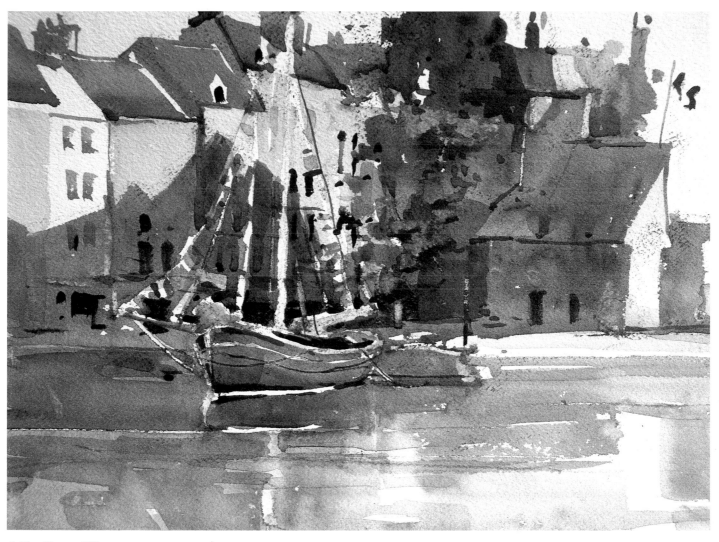

A Feeling of Peace

This painting conveys a feeling of peaceful calm because its elements are harmonious. Analogous color, smooth value transitions and static shapes help communicate that emotion.

MARILYN SIMANDLE
Honfleur Morning
Watercolor, 9" × 12" (23cm × 30cm)

Color Diversity

Diversity, or contrast, is in many respects the flip side of harmony. Harmony is based on the similarity of elements; diversity emphasizes the differences between them. Harmony conveys a sense of peace, calm and order; diversity communicates action, excitement and energy. Diversity can take many forms, and might combine characteristics of shape, color, value, line or texture.

Complementary Colors Contrast
Colors from opposite extremes of the color wheel, called *complementary colors*, contrast most strongly.

Lively Contrasts
This painting conveys a feeling of excitement and life because its diverse contrasts dominate its harmonies, though both are clearly in evidence. The oranges in this painting strongly contrast with their complement, blue.

The dark green tree mass and windows strongly contrast with the adjoining whites and oranges. Organic foliage and water shapes contrast with geometric houses. Strong vertical elements contrast with horizontal masses, edges and lines.

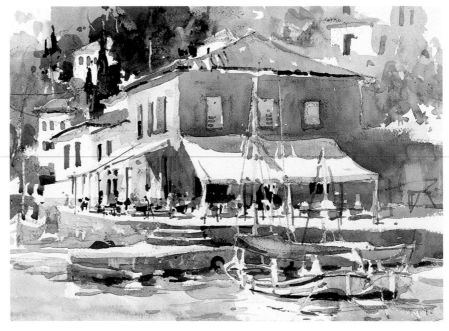

MARILYN SIMANDLE
Hydra, Greece
Watercolor, 9″ × 12″ (23cm × 30cm)

BALANCE HARMONY AND DIVERSITY

The paintings we look at affect us in many ways. Some are calm, peaceful and soothing. Others are exciting, energetic and joyful. They convey these impressions because they combine harmony and diversity to differing degrees. Harmony unifies; diversity excites. In a way, harmony and diversity are opposite sides of the same coin. Both should be present in every painting, and the degree to which each dominates and plays against the other helps determine the mood of the piece.

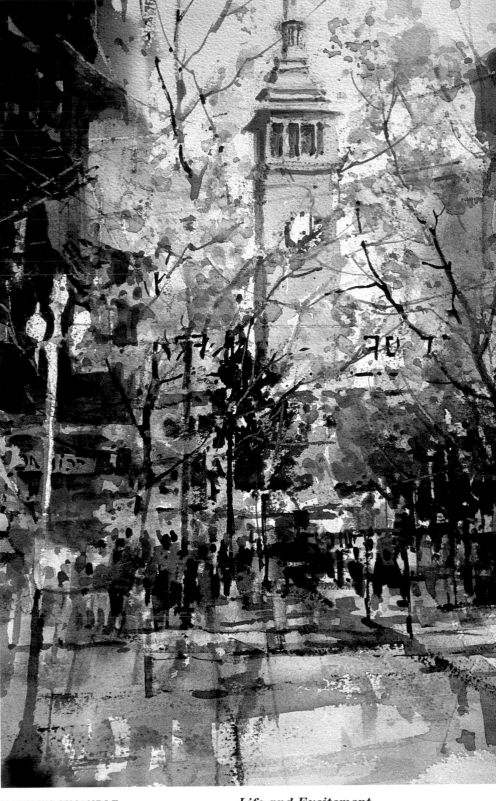

MARILYN SIMANDLE
The Ferry Building, San Francisco
Watercolor, 16"×12" (41cm×30cm)

Life and Excitement
This painting throbs with life and excitement. Bold color contrasts, strong value contrasts and dynamic shapes all help achieve that effect.

Putting It All Together

There are countless ways to balance harmony and diversity in your paintings. The mood you wish to establish in a particular painting determines just which will dominate, which is why it's so important to decide the feeling you want before you begin. The secret is in the planning; the decisions you make before your brush touches your paper make all the difference at the finish. That balance of harmony and diversity isn't something you can plug in later!

As you work your way through the rest of this book, be alert to the harmonies and diversities in each example. They are your key to answering two important questions: "What makes this painting work?" and "How can I use that to get my paintings to work?"

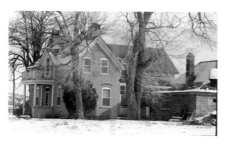

Make Decisions Before Painting
The artist photographed this house in the snow because she enjoyed its shapes and the way it's nestled in the trees. She didn't love the cinder block structure at right, however, so she moved and changed it in her composition. She also rearranged the trees to give the house more room.

1 PLAN HARMONY AND DIVERSITY WHILE SKETCHING
The artist thought of the rhythm of repeating roof shapes, a fragment of fence in the foreground and the railing of a porch as she sketched the scene. The artist planned strong vertical tree elements against the horizontal mass of the buildings. She set up the contrast of organic foliage shapes against geometric shapes of the house and also thought about color harmonies. She wanted to use an analogous color scheme ranging from green through yellow to orange. Value contrast will consist of dark foliage against the light values of the house and the background.

2 ESTABLISH COLOR RANGE
The initial wash establishes the green-to-orange color range.

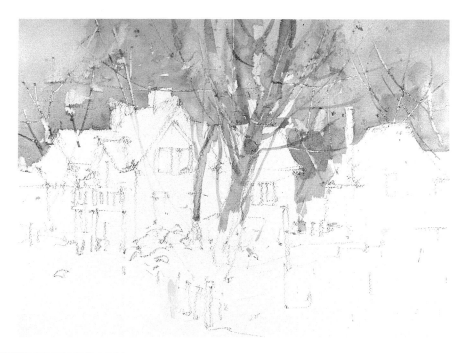

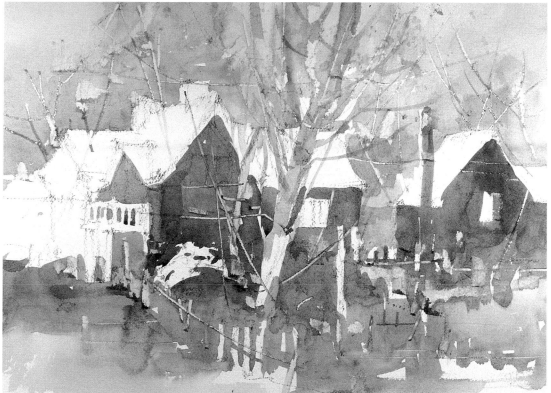

3 CREATE RHYTHMIC SHAPES
A second wash establishes a darker passage of the same color while creating the rhythmic shapes of the rooflines.

BALANCE SIMPLICITY WITH DETAIL

A painting is a form of communication that is not complete until it has evoked a response, thus achieving a conversation between artist and viewer. The conditions have to be right for that communication to happen. Too much detail in your painting leaves nothing for the viewer to imagine. It's as if you were dominating the conversation. Too little detail, on the other hand, might be compared with leaving out important words and phrases—there is neither communication nor understanding. Something between these extremes awakens viewers' imaginations with the power of suggestion, and their response completes the communication. Thus, there must be a balance between simplicity and detail.

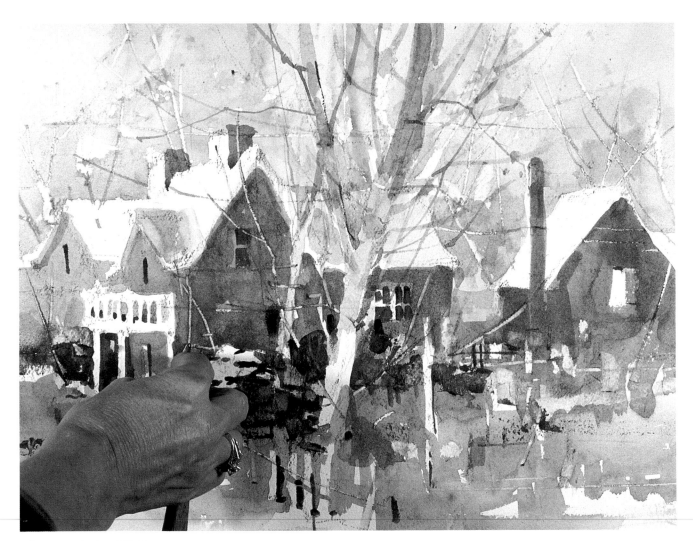

4 ADD MORE RHYTHM

With a rigger brush and a palette knife, begin to add rhythmic lines in tree branches, siding lines and such. Geometric window shapes are another instance of repeating, rhythmic shapes.

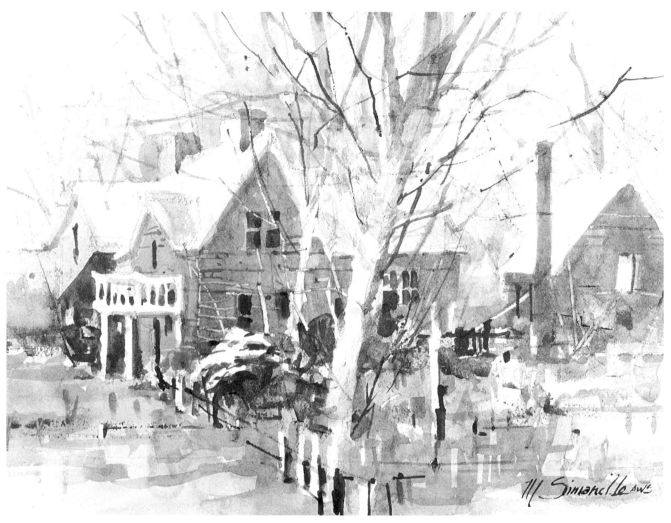

5 SET THE MOOD WITH HARMONY AND DIVERSITY

The mood of this painting is a blend of peacefulness and liveliness due to the harmony of color and shape, as well as the diversity of line and value.

MARILYN SIMANDLE
The Yellow House
Watercolor, 12" × 16" (30cm × 41cm)

Creating Brilliant Brights

PLAN IT OUT

Take a look at these two photos of Greece. Ignore the fact that the scene beside the pier was photographed in the flat light of a cloudy day: Visualize bright sunlight, dazzling white buildings and colorful boats bobbing in a sparkling harbor. It's the perfect watercolor subject! What will make this subject work is sunlight contrasting against shadowed masses. Carve out your whites by painting around them. Highlights will dazzle because they play off against color-filled shadows. Decide where the light should come from. Bringing it in from the right illuminates building facades but allows for few shadows; light from the left throws building facades into shadow, which can be used to contrast them with highlighted masts, awnings, building flanks and the promenade. Lighting from the left is the way to go!

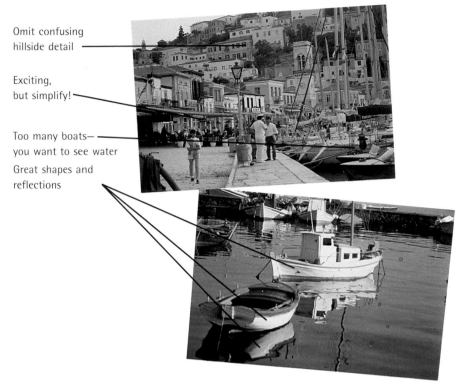

Omit confusing hillside detail

Exciting, but simplify!

Too many boats—you want to see water

Great shapes and reflections

1 START WITH THUMBNAILS AND VALUE SKETCHES

Grab your pencil and try your own interpretation of the scene with some quick thumbnail sketches. Remember to simplify values to white, middle and dark. The large building-front shadow mass frames the

scene, making highlights pop! Play with different arrangements. For example, try reversing the foreground, as in the second sketch.

When you've arrived at a value pattern, try one or more value sketches to further develop the composition. Simplify, using

fewer buildings and boats for less clutter. Distill the scene down to its essence.

See how the artist holds her pencil? Standing at arm's length from her paper and using the broad side of the lead lets her quickly sketch large, dark masses without getting bogged down in detail.

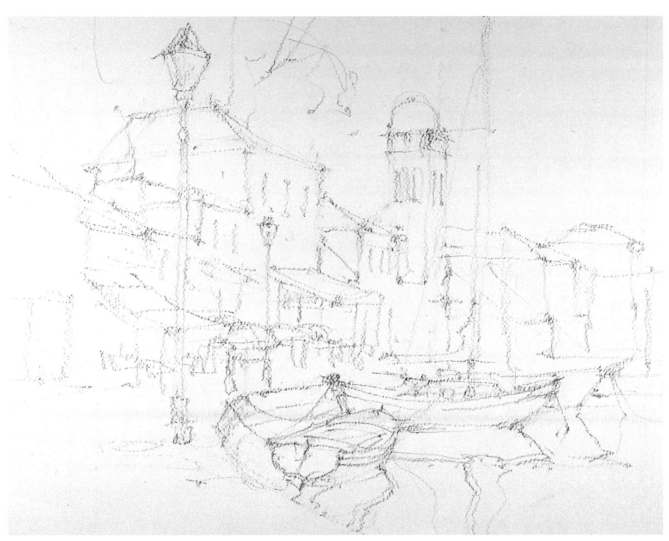

2 LAY THE FOUNDATION

Transfer your simplified composition to stretched watercolor paper, developing it as you go. This sets you in the right direction. Here the artist used the skiff from the photo, but changed the other boat's structure to that of a sailboat rig, creating a strong vertical that contrasts with the horizontals of the promenade and the buildings.

3 CARVE OUT WHITES

Beginning at top center, lay in a warm-gray mixture of Manganese Blue, Raw Sienna and Permanent Rose warmed with Cadmium Orange. Vary the hue each time you recharge your brush. Leave lots of white for masts, tree trunks and sparkle: You can always tone them down later. When you've reached the right edge, begin again at the center and work your way left. Develop the shadow mass of the buildings, moving from left to right.

5. Add Cadmium Orange and Burnt Sienna for stronger value.

1. Begin here and work to the right. Scratch in branches as you go.

2. Work in a green of Maganese Blue and Raw Sienna.

3. Use Permanent Rose and Maganese Blue for distance.

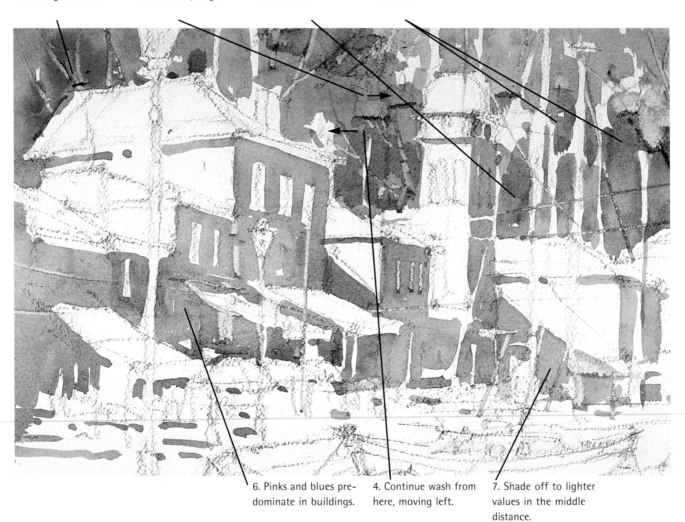

6. Pinks and blues predominate in buildings.

4. Continue wash from here, moving left.

7. Shade off to lighter values in the middle distance.

Add dark values
for contrast.

Move this blue
around the painting.
Do this with
other colors too.

The whites you
carve out are very
important! Be
sure to leave more
than you think
you'll need.

Begin to develop
the point of interest.

Use your boats as
dynamic pointing
shapes.

Using Cobalt Blue
and Permanent Rose,
add a contrasting
accent stripe.

Keep color and value contrasts subtle toward the edges.

Vary colors and values in the next largest masses—the roofs.

Tone one building with salmon for variety.

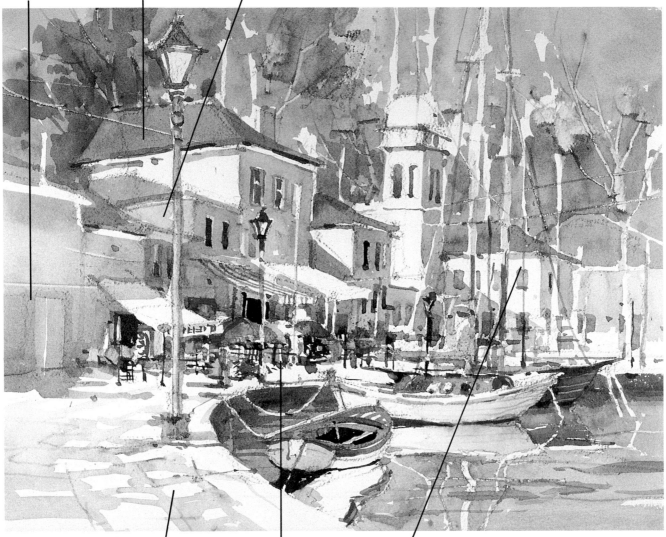

High-key wash of Permanent Rose and Cadmium Orange keeps the promenade bright and sun-drenched.

Suggest people, tables, chairs and umbrellas in the point of interest. Don't get hung up on detail! Just use shapes and values, not objects. Keep colors brightest and contrast strongest in the point of interest.

Paint masts dark against white, light against dark.

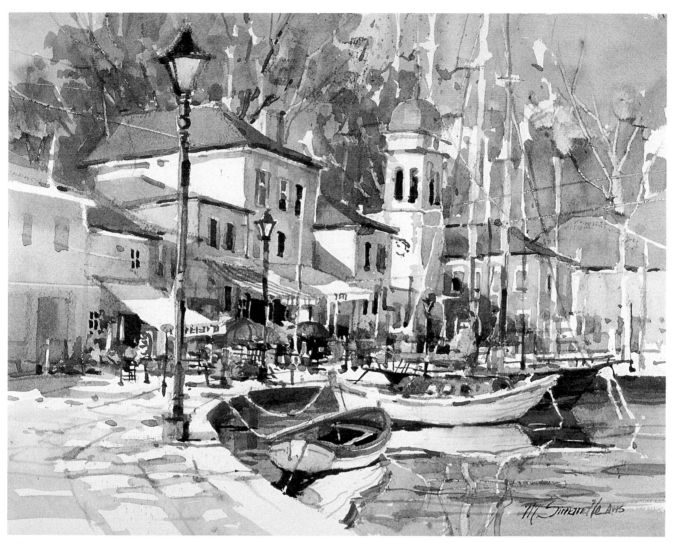

6 COMPLETE THE PAINTING

Emphasize the light and sparkle in this scene by fine-tuning values and detail. Glazing some of the dazzling white elements to a light value of yellow, pink or blue focuses attention on the remaining whites, which are primarily in and around the point of interest. Elements in the point of interest should be bright and full of contrast, and yet devoid of the kind of detail that traps the eye.

MARILYN SIMANDLE
Port Sunlight
Watercolor, 14" × 18" (36cm × 46cm)

Creating Building Textures

Barns in Pencil

Of the many things on the endangered species list, barns must be near the top. The next time you are in the country, try to get permission to look inside an old barn. If you appreciate craftsmanship, these architectural wonders will appeal to you. Whether it be the hand-hewn beams, the peg construction or the beautiful patina of the boards on the outside, you'll find something to admire. These picturesque constructions have naturally attracted artists as elements for landscapes or as close-up studies. The following drawing techniques will help you give barns the character they so richly deserve.

PLACING BARNS IN THE LANDSCAPE

Here we have two versions of a scene with the same elements: a barn, a silo and a tree sitting in a field of grass. The first is rendered fairly well, but does nothing for the viewer. There is nothing going on, no story to draw the viewer's interest. The placement of the main elements and the uninteresting field add up to a monotonous picture. The barn is fine, but it needs help.

In the second version, the barn has been repositioned. A simple sky, a background of trees, a plowed field, fence posts and grazing sheep all add interest. Note that the plowed field, the posts and the angle of the grazing field all point the way back to the barn. The barn is not overpowering, but it is still an important part of a picture that has a story to tell.

MISTAKE: Notice that this barn, though well rendered, has no supportive detail to tell its story. The barn is centered horizontally on the paper and is therefore outside of the Golden Section (described on page 24).

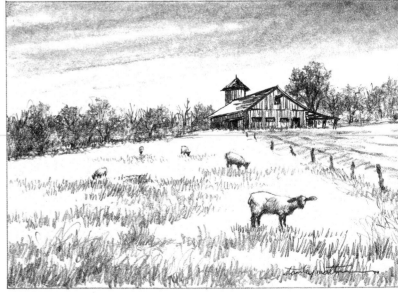

IMPROVEMENT: Now placed on one of the spots in the Golden Section, the barn is the center of the story this drawing has to tell. Both the posts and the line of trees draws the viewers' eyes toward the barn.

Drawing Barn Textures in Pencil

1 To create the beautiful sculptured wood that you see on barns on paper, select a paper with a textured surface, such as the Strathmore 400 Series regular drawing surface. Take a 2B charcoal pencil with the charcoal sanded to a 45° angle as shown. Apply the charcoal with vertical strokes, without concern that some strokes will be darker than others. Remember, you want to create rough-looking siding that has been open to all of nature's elements for years and years. This is one time that neatness does not count.

2 Once the surface is covered with charcoal, take a stomp and, again with vertical strokes only, run the stomp up and down lightly to create a gray value. Do not smooth the charcoal—that would eliminate the texture you are striving to achieve. Next, add the board widths with an HB or a B charcoal pencil. Use only vertical markings, as illustrated. Boards on this barn varied in width, since the wood was gathered from whatever trees were available at the building site.

3 Start creating the wonderful knots, knotholes and irregularities of the boards. Of course, you want to include the cracks and crevices that snow, rain and sunshine have sculpted over the years. Make some of the lines thick and others thin to account for expansion and contraction. Create knots randomly and surround them with crack lines, which run from the top of the board down to the knot, where they bend around the knot and continue their course downward. These lines should be of varying thicknesses and not necessarily parallel to each other. Take advantage of the natural variations in the paper, and add or delete tone to create all kinds of textures. Notice the shadow across the top of the drawing. You can still see some texture within the shadow area.

Sketches by Stanley Maltzman

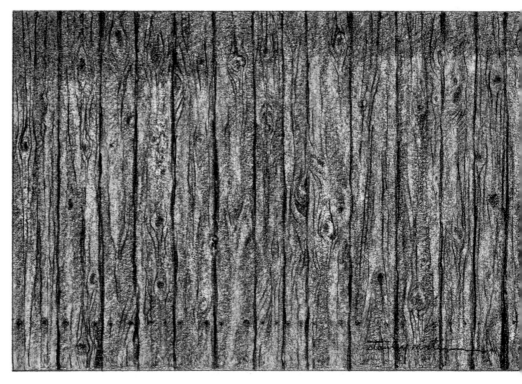

Capturing the Character of Old Barns in Pencil

Most barns have a certain personality—something that gives them character and quiet dignity. Each person will draw these barns in a different manner, because each person will see and value different things.

The first thing to do when drawing an old barn is to forget about using a T-square, triangle or ruler. The freely drawn line, rather than the mechanically correct line, will add a great deal of warmth and personality to your drawing.

When indicating boards or siding, vary the thickness of the line to indicate spaces between the boards. To show age, make the bottom of the boards irregular, with broken pieces missing. Draw the doors and windows hanging at an angle. In addition, windows can be shown with a crack or a pane of glass missing. Make the roof shingles irregular to show exposure and wear. Add unkempt grass, fence posts and other farm objects to the outside grounds.

All three of these barns were rendered with HB, 2B and 4B charcoal or graphite pencils on Strathmore 2-ply bristol.

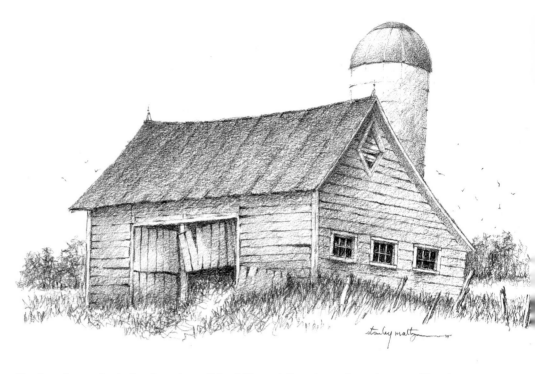

The hanging and missing boards on this old barn tell a story of great age and hard use. Notice the variations in board width above the three windows.

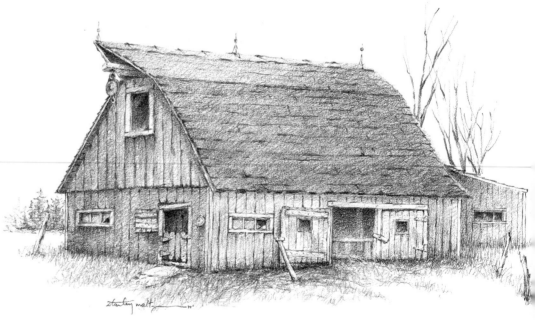

The curved roof was rendered with uneven shading and a minimum of lines to suggest shingles. Don't forget to add telling details, such as the three lightning rods along the roof's ridge.

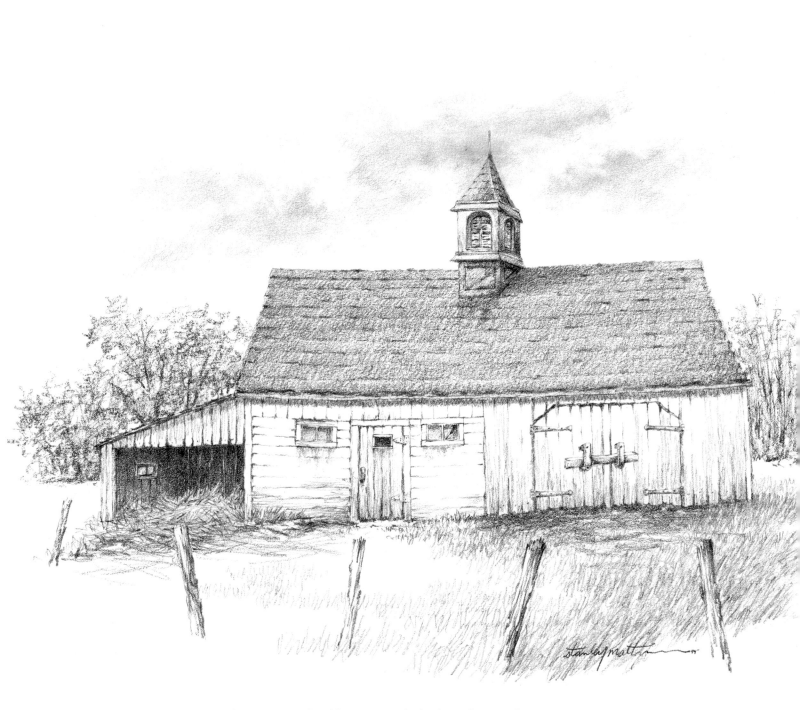

Architectural details such as the shuttered cupola add interest to the horizontal mass of the roof; sagging eaves and out-of-kilter windows lend a picturesque touch.

Sketches by Stanley Maltzman

Painting Weathered Wood in Watercolor

1 This is the gable-end view of an old wood shed. Start with a light wash of Davy's Gray over the entire area, and while the wash is still wet, brush in some Ultramarine Blue and a light red.

2 Go over the first wash after it dries with a little deeper tone of the same colors, letting the first wash show through. Indicate dark shadows under the eaves.

3 Dry-brush a reddish color over the gray and, with a small brush with the hairs spread flat, paint in the knots of the pine boards and the dark cracks between them.

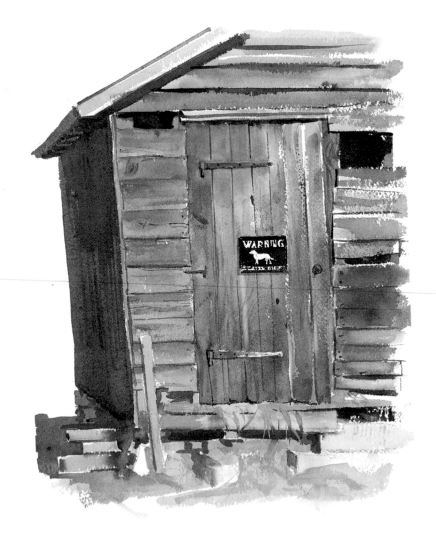

It is not difficult to achieve a feeling of weathered wood. It can be done in two or three steps. Using an old corn crib door as a subject, lay in a blended wash of grays made of a neutral tint and add a little light red and Cerulean Blue into it. After drying, take the same colors and repaint the wood with a much drier brush. The overlay should be done with a quick movement of the brush so that it skips across the paper, letting the underlayer show through. Finally, with a fine-point sable, paint in the cracks between the boards and where wood has splintered. Paint rusty strap hinges, door locks or latches in separately.

RANULPH BYE
Ramp, Fish House, Port Clyde, Maine
Watercolor, 15″×21″ (38cm×53cm)
Collection of Ms. Catherine Bye

A study in gray and green. This old fish house is badly in need of a paint job, but the artist painted it the way he saw it, weathered wood on an overcast day. He rather liked the zigzag pattern of the ramp and the lumber leaning against it. The two lobster traps on the right repeat the design in a modest way. A somber mood prevails in this watercolor. Simplicity is the key here.

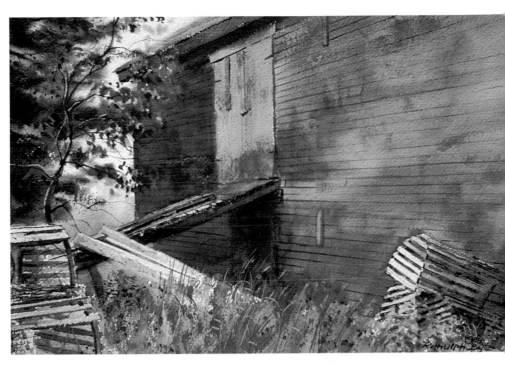

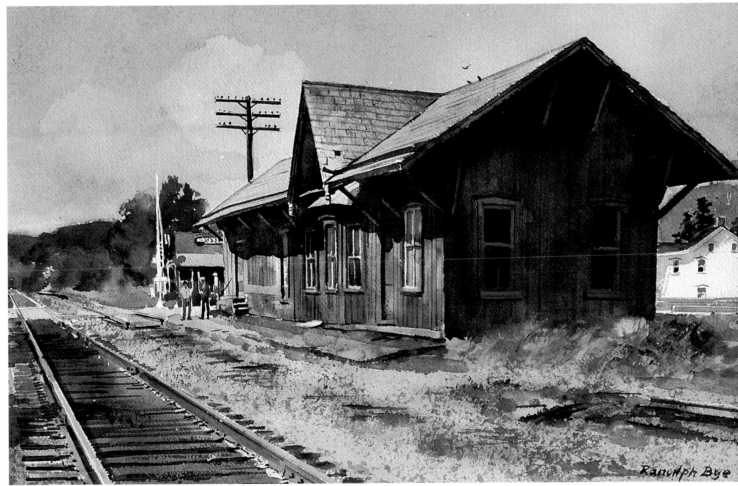

RANULPH BYE
Weissport, Pennsylvania
Watercolor, 15″×21″ (38cm×53cm)
Private collection

An abandoned railroad station in a bad state of disrepair. The dark, unpainted wood evoked a nostalgic feeling of a bygone era. The building has now been razed.

Farm Buildings in Watercolor

Farm buildings have provided good subjects for painting since the seventeenth century in Holland and England, where it all started. In our country we have a wide diversity of farm buildings in every corner of the land. Climate and availability of building material dictate how they were built.

In eastern Pennsylvania, local fieldstone and quarries were abundant; consequently, many of the barns and houses in that area are constructed from stone. In central Pennsylvania, as well as in New York and New England, timber was the main source of building material.

Farm buildings seem to be popular painting subjects because of their simple shapes and compatibility with the landscape. They can offer a strong design and a color note to an otherwise commonplace landscape. Very often, surrounding outbuildings provide a variety of sizes and shapes. These, combined with a barn, silo, springhouse and farm animals, produce a ready-made composition that can be painted from many viewpoints and in any season.

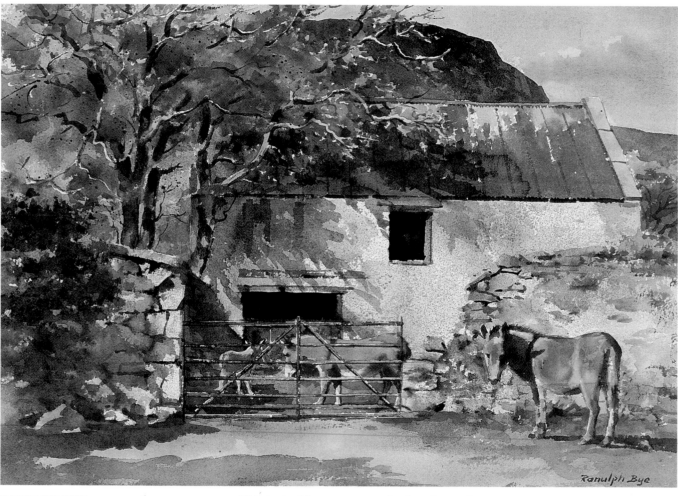

RANULPH BYE
Barnyard, Road to Mulrany
Watercolor, 15" × 21" (38cm × 53cm)
Collection of Mr. and Mrs. Ranulph Bye

This typical farm scene can be found anywhere in the Irish countryside, but the crumbling wall defines it as an old place. The donkeys roaming about are common and are often used to pull carts or carry peat. This subject was so inviting and the placement of picture components so satisfactory that there was very little rearranging to do. There is a grayish oil-and-turpentine patina over all stone and wall areas to give texture. (The patina technique is described on page 68.) The play of light and shadows give sparkle to the scene.

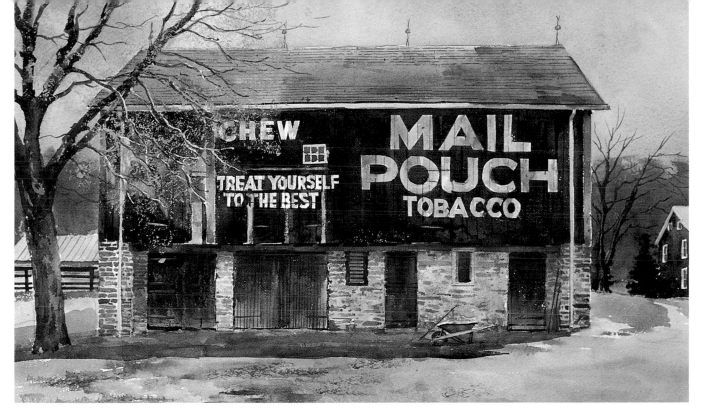

RANULPH BYE
Chew Mail Pouch, Klinesville, Pennsylvania
Watercolor, 16″ × 24″ (41cm × 61cm)

These barn signs are a vanishing landmark. It is a form of cheap outdoor advertising from which a farmer derived a small revenue. Why only flour and chewing tobacco brands chose this method to display their names is a mystery. This watercolor is painted from a dead-center position, causing all vertical and horizontal lines to be at right angles to each other, which fits well into the rectangular format of the painting.

RANULPH BYE
Vermont Farm
Watercolor, 15″ × 20½″ (38cm × 52cm)

This dilapidated barn is almost dwarfed by the towering silo beside it. The artist masked out the sheep before laying in the green pasture. The barn, trees and shadows were painted in next with mixed shades of red, blue, green and sepia; the painting was all done in one afternoon.

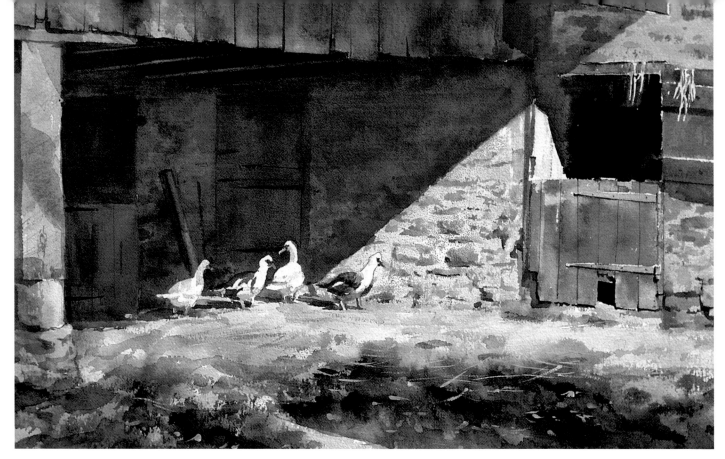

RANULPH BYE
Under the Overhang
Watercolor, 14½" × 20½" (37cm × 52cm)

A barnyard study on the Farbotnik farm. It is a quiet moment at this old farm, with a few ducks gathered together in the sunshine. Notice how the sharp diagonal shadow directs the eye to the center of interest. By being close to the subject the artist was able to render the texture of old stonework, time-worn barn doors and scattered straw in the foreground.

RANULPH BYE
Behind the Barn
Watercolor, 21" × 29" (53cm × 74cm)

This watercolor was painted early in the morning. A light streak was shooting across the middle ground, with shadows thrusting spears of dark into it. Ducks in the foreground provided a center of interest. The play of warm and cool tones gives harmony to the wintery mood.

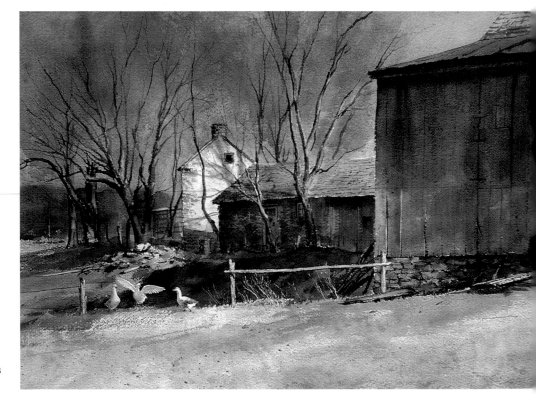

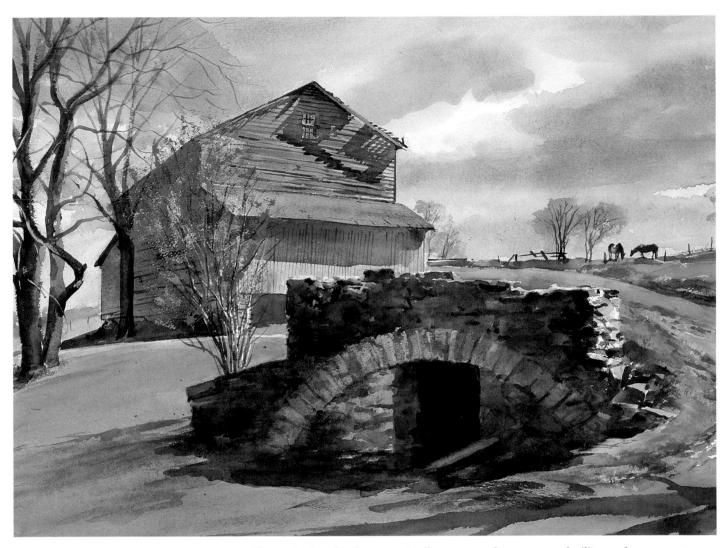

RANULPH BYE
Root Cellar, West Amwell, New Jersey
Watercolor, 18½" × 26" (47cm × 66cm)

Not easily found today, a root cellar was a rather common facility on farms a century ago. This one descends underground a few steps below ground level and was used to store perishable produce over the winter. The room below might be 8 × 10 feet square (2.4m × 3m), with masonry walls and ceiling.

It was March and the trees were bare, but the grass had started to turn green. This piece was painted directly on location over a two-day period. Strong lights and shadows come in from the right.

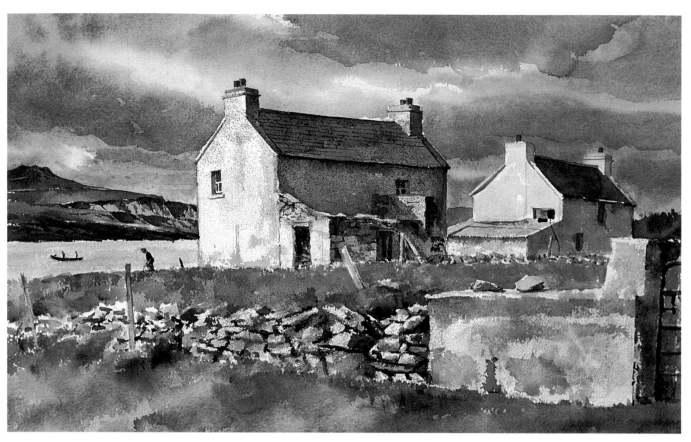

RANULPH BYE
Dooega, Achill Island, County Mayo, Ireland
Watercolor, 14½" × 21" (37cm × 53cm)

Ireland has a stark landscape with a barren coastline where this watercolor was painted. The proliferation of stone everywhere gives the people the means to erect dwellings, barns and fences with this material. The lively sky adds movement to the grim severity of the farmhouses. Sheep always seem to be roaming about, so the artist put them in.

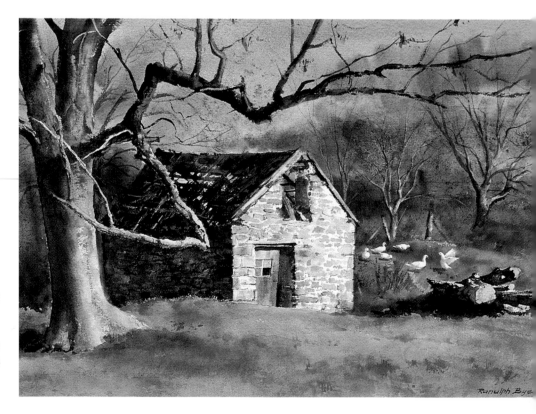

RANULPH BYE
Springhouse
Watercolor, 15" × 21½" (38cm × 52cm)

It is late fall on the Farbotnik farm; the trees are bare but the air is still warm and the front of the springhouse glows in the morning light.

The broken roof has been repaired since this watercolor was done. One ash tree has succumbed to old age; the other still stands, alone.

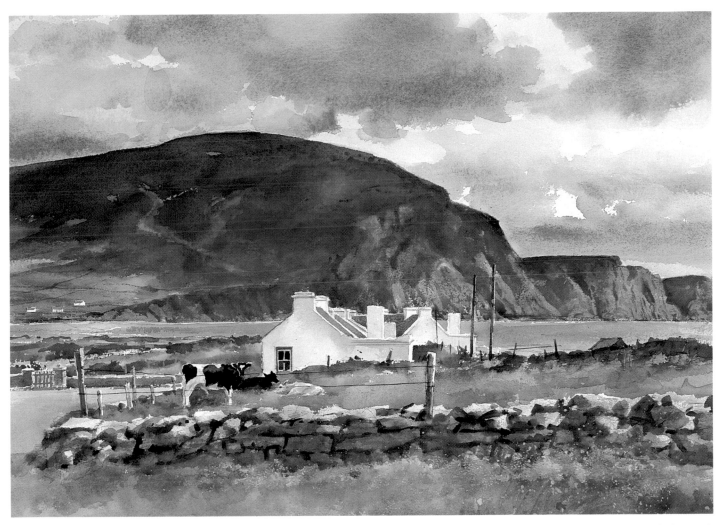

RANULPH BYE
Cathedral Cliffs, Achill Island, County Mayo,
Ireland
Watercolor, 19¼″×28½″ (49cm×72cm)
Collection of Mr. and Mrs. Ranulph Bye

Ireland is a country of spectacular scenery. Along the coast it can be overwhelming and, because it is sparsely wooded, there is nothing to obstruct the view. Skies play an important part in this country, and clouds are almost always present. Shafts of light break through cloud masses, causing brilliant spots of color on the countryside.

The cluster of houses shown here, surrounded by a lush pasture bordered by the ever-present stone fences, is typical in any part of the country. The clouds above caused the mountain to be dark in shadow, with a rich bluish green color. To get the subtleties of this dark mass, the artist went over it several times, one wash over the other. Some lifting out of the color was done later to bring out certain forms. Opaque flecks of yellow flowers in front completed the watercolor.

Contrasting Snow and Weathered Wood in Watercolor

This is the artist's latest painting of the Farbotnik farm, which has been one of his favorite subjects for years.

It had just snowed on Farbotnik farm, and by walking around, the artist discovered this composition with a horse and barn nicely related in tone and value. The light snow contrasted beautifully with the old gray barn, and he intended to pay close attention to the texture of stone and wood. Keeping the snow-covered foreground simple enhanced the rest of the picture. The old mare was unconcerned about her part in the painting and was content to stand still with her back to the warm sun.

1 Draw in your composition. Use a photograph if you like. Notice that the barn on the right was purposely cropped to create a stronger design. Be careful to draw the horse a little to the right of the center.

Mask out all areas except where stonework appears on the end wall of the barn and along the foundation, and then apply an oil-and-turpentine patina on the exposed areas. (See pages 68-69 for a description of how to apply an oil-and-turpentine patina.)

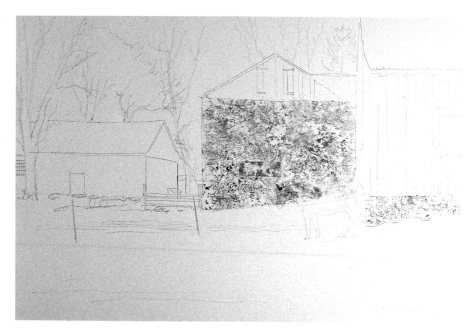

2 Apply a light wash of Burnt Sienna over the entire sky, barn and outbuildings, leaving white paper for the snow-covered roof areas and the foreground.

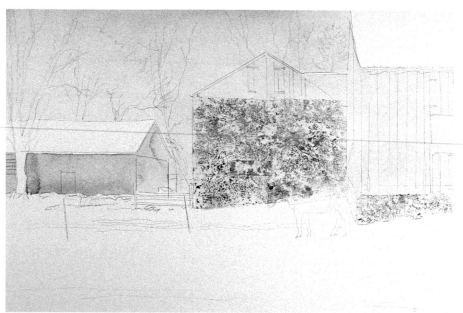

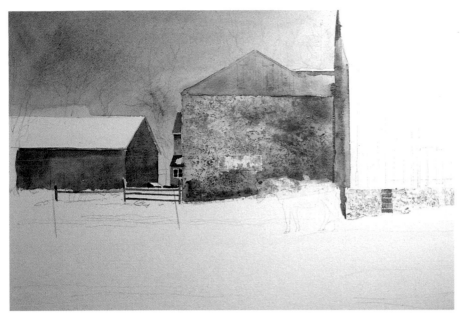

3 Apply preliminary washes of warm and cool gray over the buildings. Paint in a light
blue sky (Cerulean Blue with a touch of Cobalt) with a yellowish tone for tree
branches brushed in wet-into-wet. Add the house behind the barn.

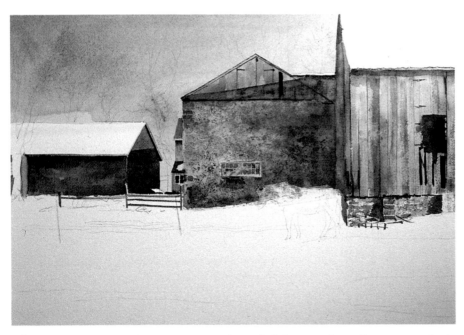

4 Use another wash of warm gray over the end of the stone barn. To create vertical
siding on the right, use Davy's Gray, a light blue and Ochre, and then dry-brush
afterward with deeper values of the same colors. Lift out some color at this point,
because weathered wood is anything but a flat tone.

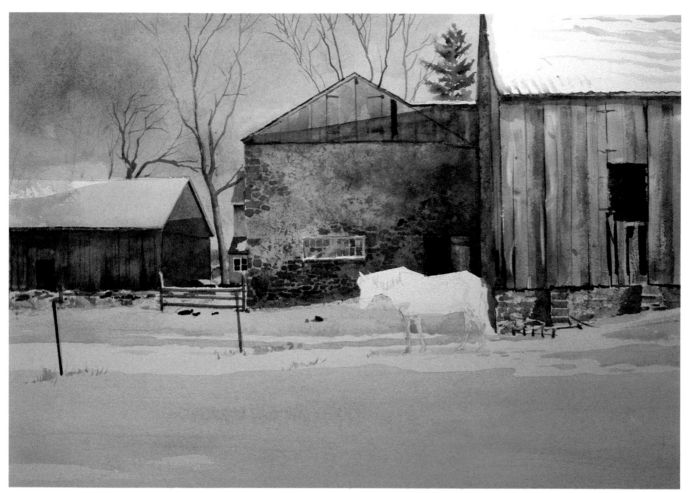

5 Lay in a very pale wash of Alizarin Crimson over the entire snow-covered area. In late afternoon, snow appears slightly pink. Wash in the snow shadows in the foreground with a mixture of pale Cerulean Blue and Cobalt Blue. (Mask out the horse first to facilitate running a wash behind it.) Further develop the weathered vertical boards by suggesting knots and cracks between the boards. Start the stonework on the end wall, lay it in stone by stone and vary the color. The stones are varying shades of blue, Ochre and light red. Lightly paint in the trees in back.

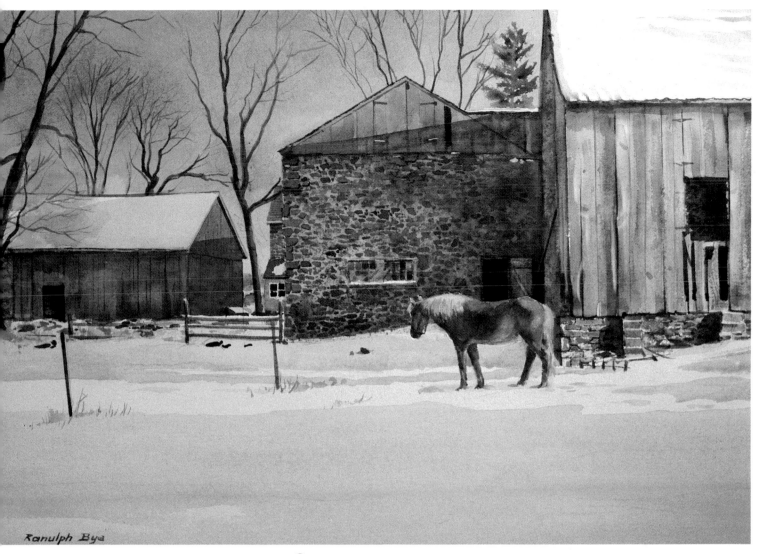

RANULPH BYE
Farbotnik Barn
Watercolor, 17" × 25¼" (43cm × 64cm)

6 In this final step, paint in the horse and finish the large maple on the left. Put in the rest of the stones on the end wall, paying particular attention to their irregularity.

This subject presents an opportunity to render both weathered wood and stonework in a single work. This is not a harsh winter landscape with strong darks and vividly blue shadows in the snow, but rather a more subtle interpretation evoking a soft light casting pale shadow tones on the ground and buildings.

Painting Brickwork in Watercolor

1 With a straight-edge, rule out brick courses lightly in pencil. Take a no. 4 square-tipped sable and brush in single bricks side by side. Each course should overlap joints above and below. Vary the color from a light red to Indian Red or a warm gray.

2 Fill in joints with Davy's Gray or Naples Yellow.

3 With a fine-point brush, indicate side and bottom shadows under each brick with pale blue.

BRICKWORK UP CLOSE

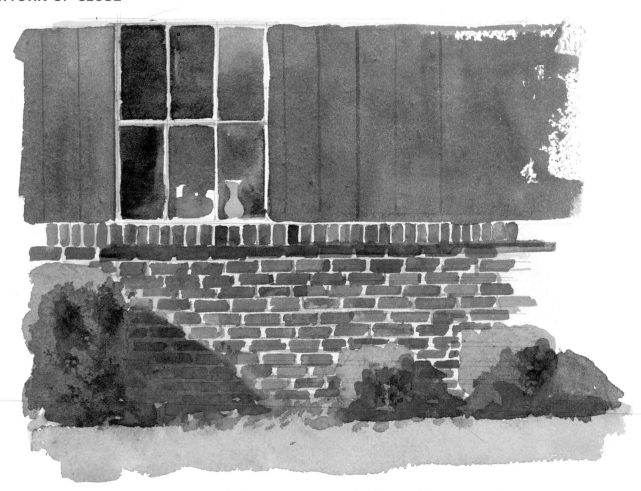

RANULPH BYE
Small Study of a Brick Wall on a Commercial Building
Watercolor, 6" × 10" (15cm × 25cm)

The simplest way to render a brick wall of this type is to lay a light wash of Naples Yellow or Davy's Gray on the paper first. Vary the color so that the bricks are not identical. From close proximity the bricks will have thin undershadows. The color of the bricks in this demonstration ranges from blue to brown and different shades of light and Indian reds.

BRICKWORK FROM A DISTANCE

RANULPH BYE
Storefronts, Danville, Pennsylvania
Watercolor, 14½″ × 20½″ (37cm × 52cm)

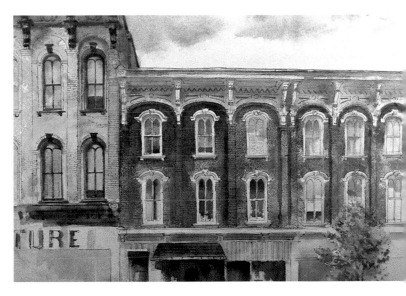

This is a fine example of Italianate bracketed buildings with much refinement in ornamentation. The front facades are made of brick; the cornices and trim are made of wood. To give texture to the brickwork, mask out everything not made of brick. Then make a solution of a light red oil paint and turpentine and sprinkle it on the wet paper. This gives a good patina to work upon. To create a feeling of brick without a lot of detail, render various sections of the front with pen and brown ink, picking out courses of bricks here and there. In painting any building from a distance of one hundred feet or more, it is best to suggest a few bricks or stones, rather than rendering each one you see. Overall colors and values are more important.

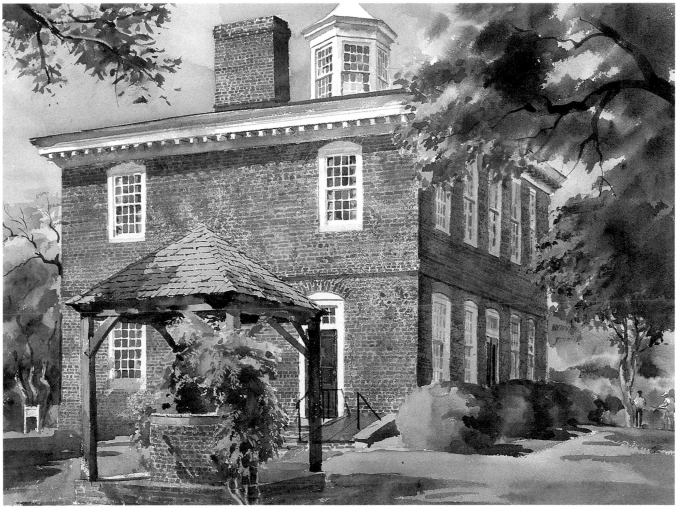

RANULPH BYE
William Trent House, Trenton, New Jersey
Watercolor, 22″ × 28″ (56cm × 71cm)

This Georgian-style house was built in 1719. Rendering the detailed brickwork takes quite a bit of time. Be careful to lay each course of bricks in the proper perspective. Although it appears each brick is individually painted you can skip across the paper in some places. Good lighting is important in this study.

Weathered Surfaces in Watercolor

In the demonstrations that follow, you will find subjects that evoke a timeworn feeling. Time and weather have left their mark, and they are manifested through surface texture. An old stone building has more of a gray appearance than a new one. Bricks collect dust and grime from the atmosphere. Unpainted wood dries out and starts to crack and warp. The natural color of the wood comes through where paint has worn away. These textures can present a challenge to the artist.

By employing the oil-and-turpentine technique, this feeling can be expressed very well. You will find this method in three of the demonstrations shown here. (The following is an explanation of this special technique.)

OIL-AND-TURPENTINE PATINA

Use an oil-and-turpentine patina when you encounter a subject with stone and plaster texture, and also for gravelly and uneven ground surfaces. It gives amazing results.

First, mask out, with newspaper or tape, all areas not to be affected—in this case the wood window and foreground areas. Next, put a small amount of turpentine in a shallow cup and squeeze out some light brown, blue and Yellow Ochre oil paint onto a palette. Very little color is needed. The color you selected can be cool or warm, depending on the color of the surface you are painting. Take a 2-inch (51mm) watercolor brush and use water to thoroughly wet the areas not covered by newspaper. With another brush, preferably a bristle brush, mix the turpentine very thinly into the oil color. Immediately sprinkle the paper with oil color while it's still very wet. You will notice that the oil color will create a fluid reaction on its own and will separate into channels. Never touch the paper with the brush: only spatter with it.

The paper must lie perfectly flat while you let it dry for a couple of hours. The resulting patina should give you a finely textured surface on which to continue your usual watercolor method.

1 Place masking over any areas to be saved as white.

2 Brush the open area with water.

3 Using your oil brush, mix a small amount of oil paint with turpentine.

4 Sprinkle the wet paper with oil color. Don't touch the brush to the paper.

5 Remove the masked area from the paper. Let it dry for two hours in a perfectly flat position.

6 After creating the patina surface, you are ready to continue painting the barn. The painting is about half finished.

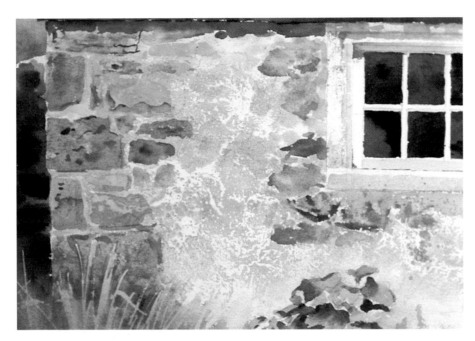

7 Here's the finished painting. Notice how the patina shows through the stonework, giving it added texture.

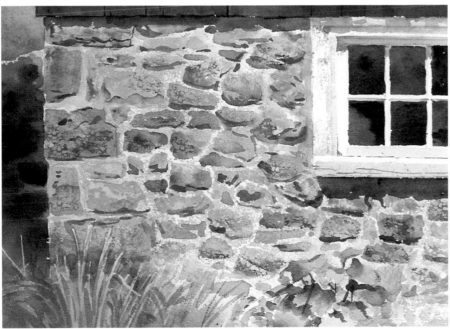

Painting Stonework in Watercolor

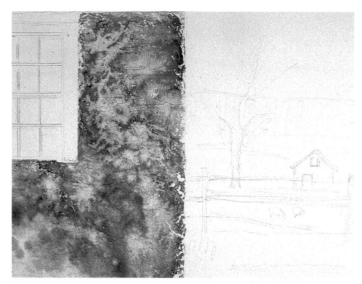

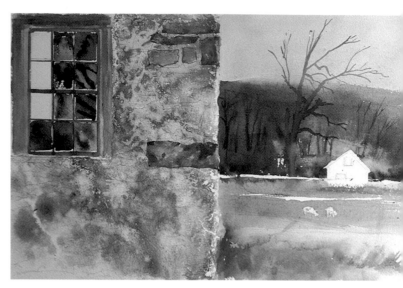

1 Draw the composition—the placement of the wall, window, landscape and the springhouse in the middle distance—in pencil. To make the stone texture more convincing, use the oil-and-turpentine patina for the underpainting (as demonstrated on the previous pages). Mask out the window and distant landscape first, and then apply the spattering method for the patina and let it dry.

2 Remove the masking and proceed to paint in the sky, the back-woods and the foreground wet-into-wet. Lay in the individual stones one by one, following your pencil outline. Near the ground line, let the stones soften and blend together.

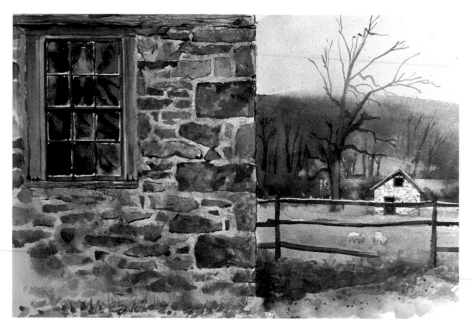

3 With all of the stones in place, add the window, paying careful attention to the re-flections of each pane of glass. Finally touch up the fence, springhouse and trees.

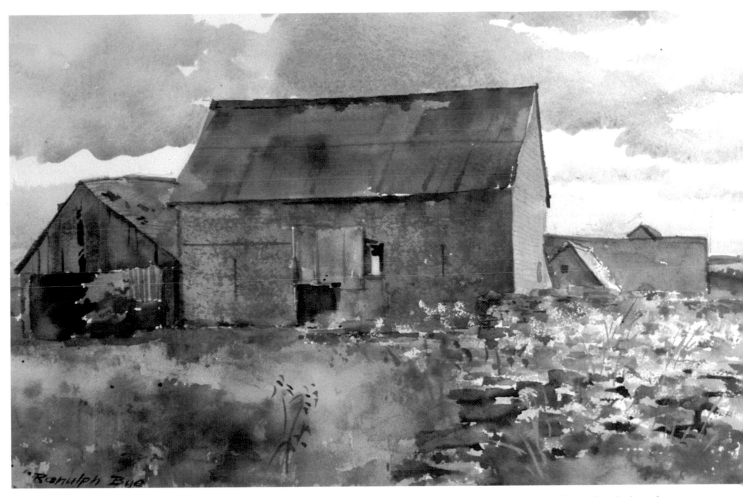

RANULPH BYE
Stone Barn in Cotswolds, England
Watercolor, 11" × 17" (28cm × 43cm)

The artist painted this farm landscape in an English village as a working sketch for a larger watercolor. On a stretched sheet of paper, he drew in the barn, stone wall and outbuildings. Since the clouds are the lightest in value, he painted them in first with a mixture of Cerulean Blue and a light red. The village had a predominantly gray appearance, so it became necessary to use some ingenuity and color license to "push" color into the gray areas. The stone colors ran from ochres to browns and bluish grays. The foreground and stone wall were painted in rather loosely, with just enough detail to tell what's what.

Stone retaining wall

This sketch shows a more formal pattern of masonry where all the blocks are rectangular. The color of the stones varied only slightly; to give them some feeling of solidity, the artist outlined them on the shadow side with a blue gray.

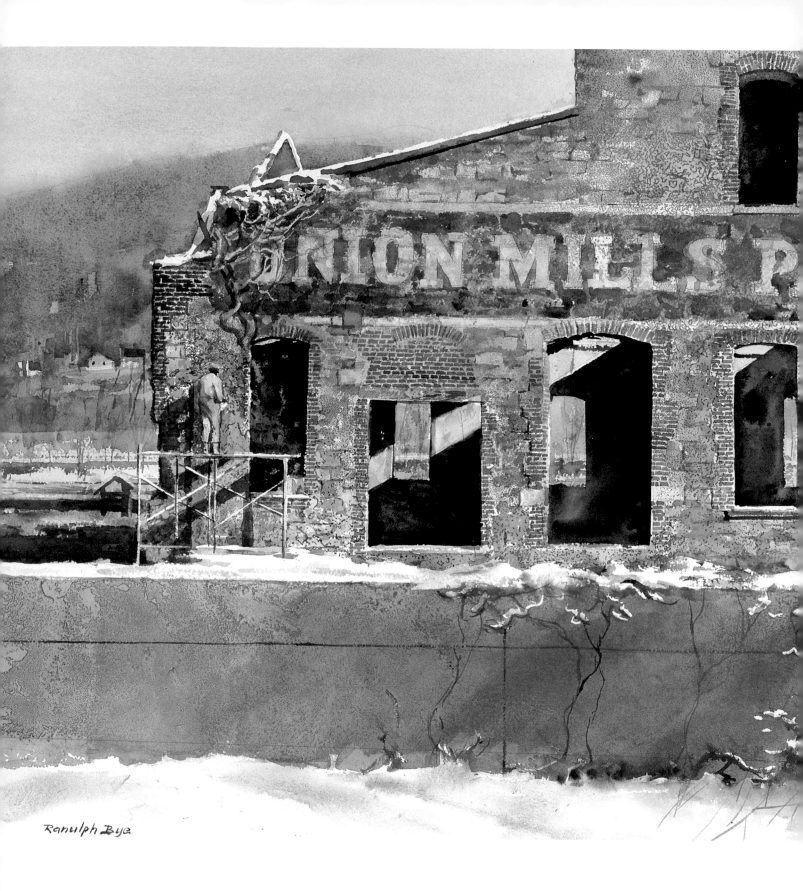

Ranulph Bye

RANULPH BYE
Union Mills, New Hope, Pennsylvania
Watercolor, 29"×42" (74cm×107cm)
Collection of Mr. and Mrs. Louis DellaPenna
Franklin Mint Award, Philadelphia Watercolor
Club, 1988

This old paper mill along the Delaware River had long ago ceased making paper, had fallen into disrepair and had been damaged by fire. In the late 1980s, developers renovated the remains along a quarter-mile section of the riverbank, and it was during that stage that the artist came upon the mill by accident and found this compelling composition. This subject offered a wonderful opportunity to underpaint all the stone and plaster surfaces with an oil-and-turpentine patina, almost the entire sheet. The mill itself extended hundreds of feet both to the right and the left of this chosen spot, but the artist cropped out everything except this one section. The Delaware Canal runs along the bottom third of the painting but it is now empty of water. A touch of snow clings to the canal wall and top surfaces here and there. A diagonal shaft of light on the inside wall offsets the rectangular black holes of the window openings. A worker stands on a scaffold repainting a section of brick wall. This was a studio work occupying several days of painting time, but the artist returned to the subject a number of times to observe color, light and texture. The whole color scheme is muted, and the artist used subtle mixtures of pinks, grays, umbers and ochres. Window openings are pure black.

Sandstone in Mixed Media

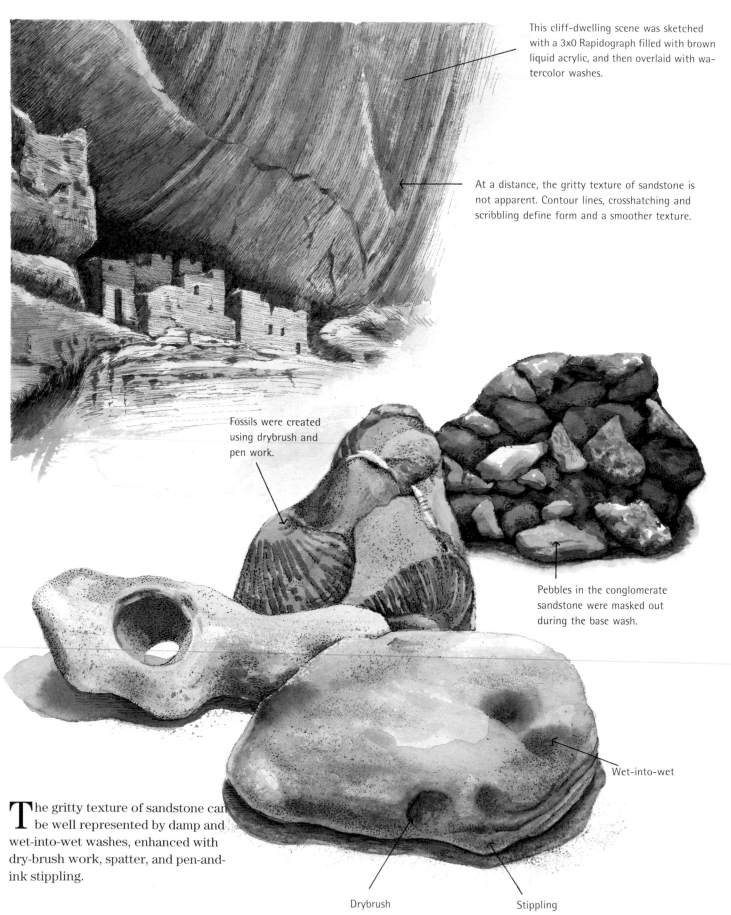

This cliff-dwelling scene was sketched with a 3x0 Rapidograph filled with brown liquid acrylic, and then overlaid with watercolor washes.

At a distance, the gritty texture of sandstone is not apparent. Contour lines, crosshatching and scribbling define form and a smoother texture.

Fossils were created using drybrush and pen work.

Pebbles in the conglomerate sandstone were masked out during the base wash.

Wet-into-wet

Drybrush

Stippling

The gritty texture of sandstone can be well represented by damp and wet-into-wet washes, enhanced with dry-brush work, spatter, and pen-and-ink stippling.

Adobe and Brick in Mixed Media

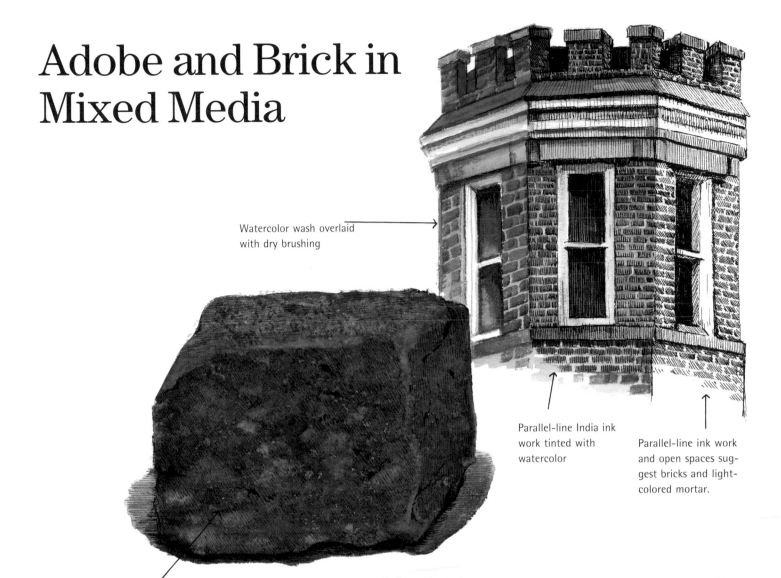

Watercolor wash overlaid with dry brushing

Parallel-line India ink work tinted with watercolor

Parallel-line ink work and open spaces suggest bricks and light-colored mortar.

Close-up Brick
Begin with layers of varied English Red/ Alizarin Crimson washes, muted with Payne's Gray. Let dry. Texture with sponge-work and parallel ink lines.

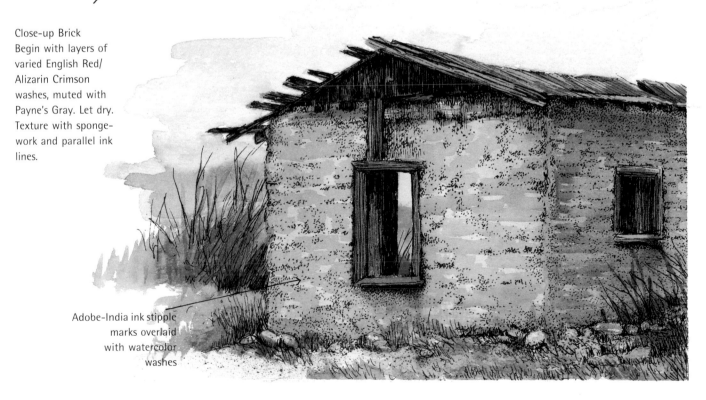

Adobe-India ink stipple marks overlaid with watercolor washes

Stone Masonry in Mixed Media

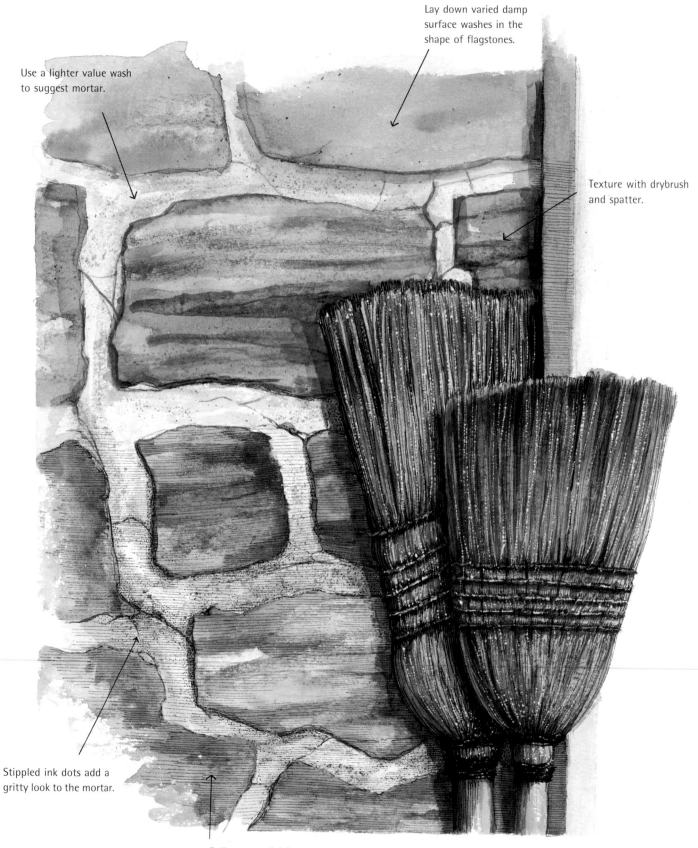

Lay down varied damp surface washes in the shape of flagstones.

Use a lighter value wash to suggest mortar.

Texture with drybrush and spatter.

Stippled ink dots add a gritty look to the mortar.

Delicate parallel lines flatten the appearance of the wall.

(Pen sizes 4x0 and 3x0 were used)

Stone Walls in Mixed Media

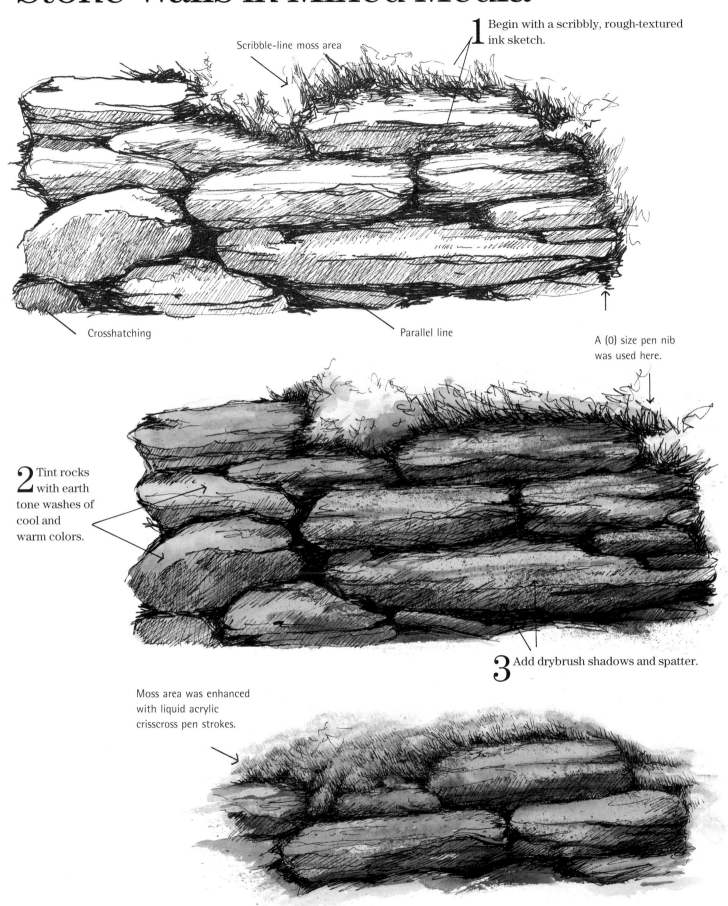

Scribble-line moss area

1 Begin with a scribbly, rough-textured ink sketch.

Crosshatching

Parallel line

A (0) size pen nib was used here.

2 Tint rocks with earth tone washes of cool and warm colors.

3 Add drybrush shadows and spatter.

Moss area was enhanced with liquid acrylic crisscross pen strokes.

Weathered Wood—Old Paint in Mixed Media

Varied damp surface wash

Masked with liquid frisket

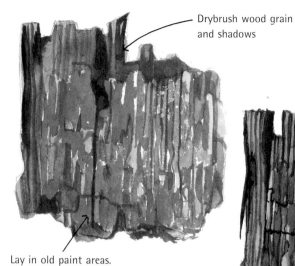

Drybrush wood grain and shadows

Lay in old paint areas.

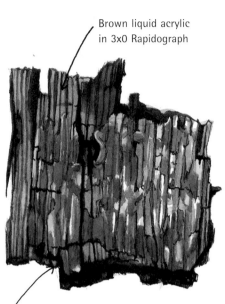

Brown liquid acrylic in 3x0 Rapidograph

Deep cracks defined with pen and India ink

Begin with damp surface and a off-white wash.

While still damp, brush in brown, wavy line streaks.

Use round brush to detail wood grain, cracks, holes and shadows.

Spatter to provide textural variety.

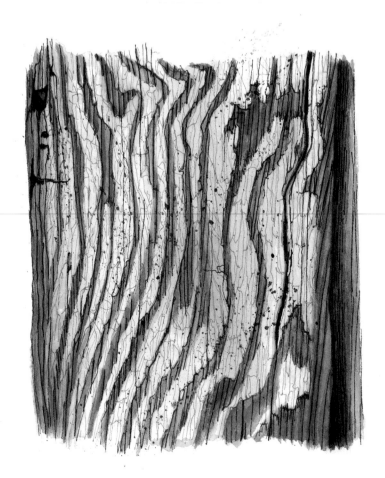

Add fine details with pen.

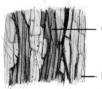

Create wood grain with strokes of India ink.

Paint cracks were penned using earth tone liquid acrylic.

Aged Fencing

PEN WORK

Scribble

Wavy line

At a distance, wooden fencing is portrayed simply with just a hint of drybrush and pen-and-ink detailing.

Seen up close, texture becomes very important. The weathered wooden post (left) was textured heavily with pen and ink, and then further enhanced with watercolor washes, drybrush, spatter and fine splashes of alcohol.

Aged Wooden Shakes in Mixed Media

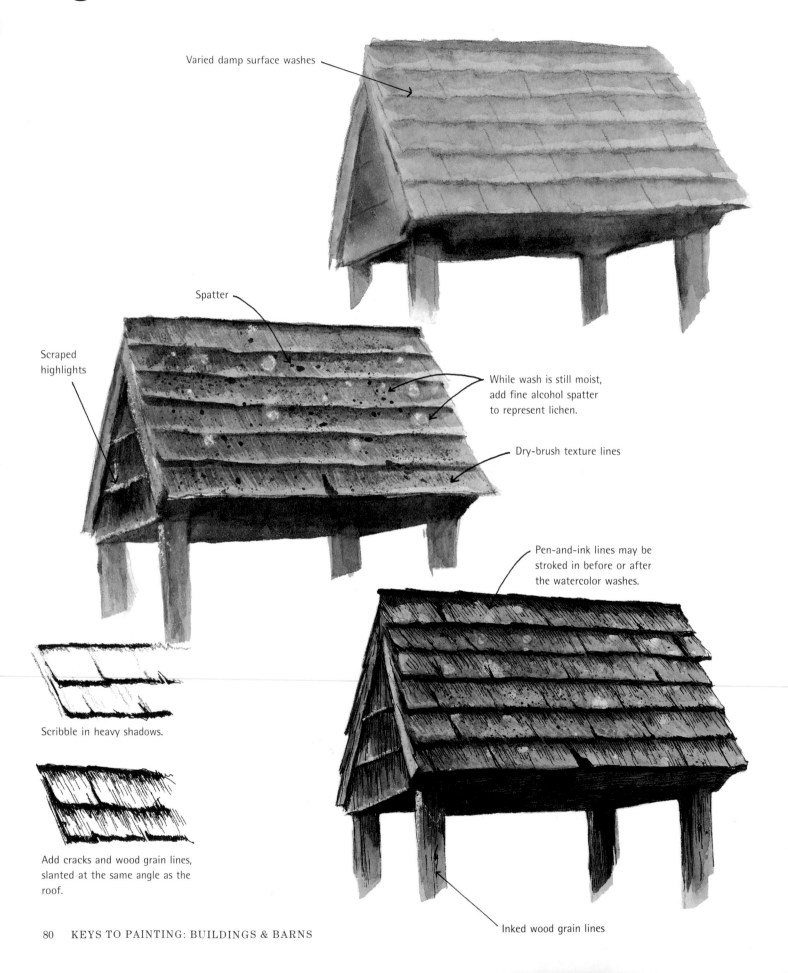

Varied damp surface washes

Spatter

Scraped highlights

While wash is still moist, add fine alcohol spatter to represent lichen.

Dry-brush texture lines

Pen-and-ink lines may be stroked in before or after the watercolor washes.

Scribble in heavy shadows.

Add cracks and wood grain lines, slanted at the same angle as the roof.

Inked wood grain lines

Old Wooden Structures in Mixed Media

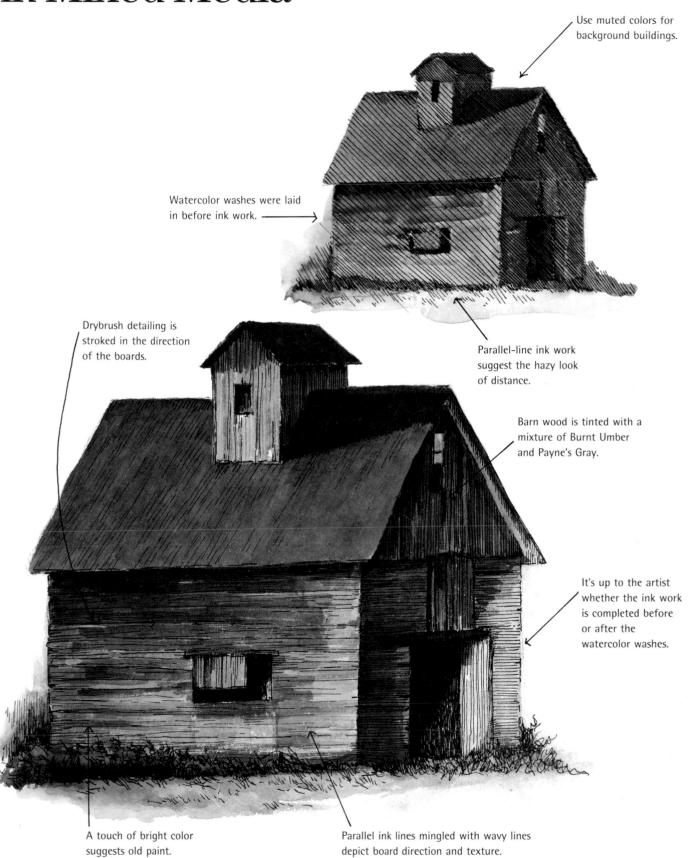

Use muted colors for background buildings.

Watercolor washes were laid in before ink work.

Parallel-line ink work suggest the hazy look of distance.

Drybrush detailing is stroked in the direction of the boards.

Barn wood is tinted with a mixture of Burnt Umber and Payne's Gray.

It's up to the artist whether the ink work is completed before or after the watercolor washes.

A touch of bright color suggests old paint.

Parallel ink lines mingled with wavy lines depict board direction and texture.

Demonstrations in Watercolor, Acrylic and Oils

DEMONSTRATION ONE: WATERCOLOR

Painting a Farmhouse

TOM HILL

"If you live in a desert climate, as I do," says Tom Hill, "it is always a pleasure to drive through the farmlands of the Midwest and enjoy the green fields, shady trees, the farm buildings and all the paraphernalia that go with farming. There's one good painting subject after another!"

The farmhouse shown at right is typical of many in Ohio. To Hill it looked like a good subject for a painting—especially as it was situated on the crest of a small hill, was old enough to have a nostalgic kind of character and, in the morning sunshine, presented some interesting light and shadow patterns to work with in the painting process. The

huge trees offered exciting shapes that could be used to set off the shapes of the building, but would need some editing so as not to appear to dwarf the house. He felt the straight road could be made more interesting too, and it was capable of adding some dynamics to the composition.

After setting up his painting gear and starting to study the painting possibilities by making compositional-value studies, it seemed to Hill that there was a certain sameness in the greens that were everywhere in the scene, and these greens could be modified and changed in favor of the painting.

No one was in sight when Hill began,

but after a while, a pickup truck approached and passed him. He decided to put that truck in the picture, under the trees, and to have a figure alongside it as well. This would give life and scale to the scene.

PAINTING GOAL

"I want to take this scene of a sunny, late-summer morning and a neat old white farmhouse on the brow of a gentle hill and create it from a painting that would describe the feeling of the scene even more succinctly than the scene itself," says Hill.

There's a straightforward look about this neat, white farmhouse—functional, not too fancy, with rather simple windows, doors and rooflines. Still, it portrays a comfortable and homey feeling, and almost seems to represent an America of simpler and more honest times that existed not too long ago.

Hill positions himself across the road from the house and gets started with his rough sketches. For an easel, he uses an aluminum case attached to a tripod; the idea is to carry everything in one "suitcase," so to speak. "It works OK," says Hill, "though I found I have to steady it a bit when painting small details."

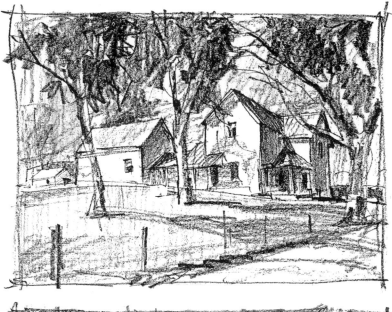

First Hill tries featuring *all* of the farmhouse framed by the trees, with the road a minor element. After studying it, he feels it is too centered.

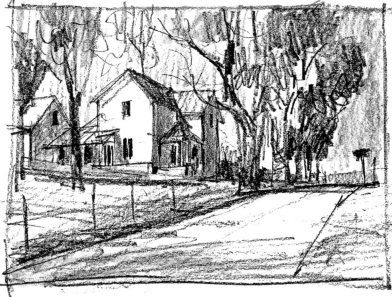

Here he moves the building off center, losing some of it to the left. This seems better, but the straight road makes everything seem a bit static and not too exciting.

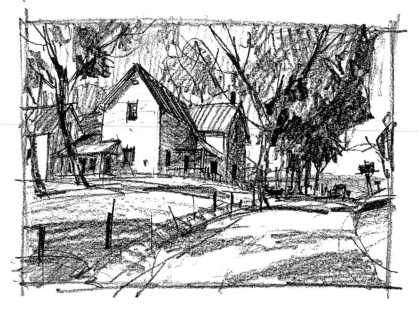

This is the rough Hill likes best. The curved road adds a bit of movement and helps lead the viewer's eye into the interesting shapes, light and shadow patterns and details of the house and its surroundings. From this rough, he pencils in the drawing on his watercolor paper.

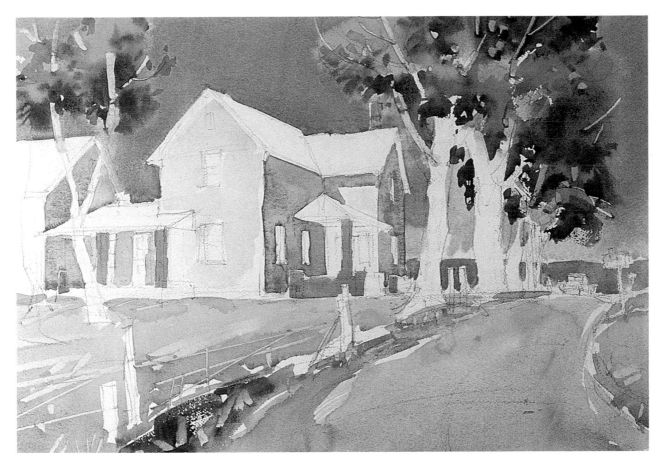

1 After painting the sky area on dry paper, charge in some of the tree foliage while the paper is still damp. Hill makes the grass area yellower to relieve some of the greenness of the setting.

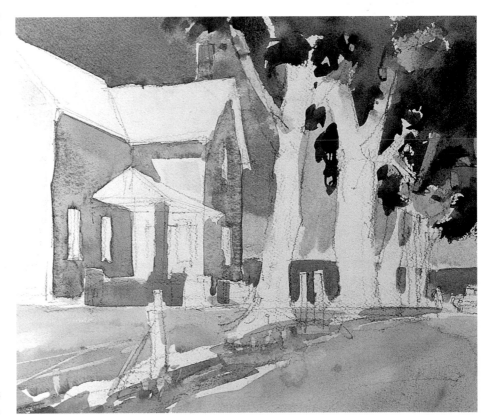

DETAIL Here you can see how both warm and cool hues were mingled in the same flat washes on the shadowed walls of the house.

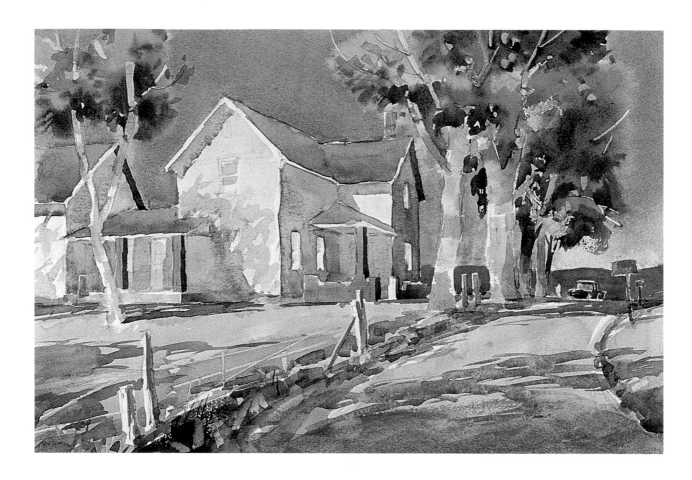

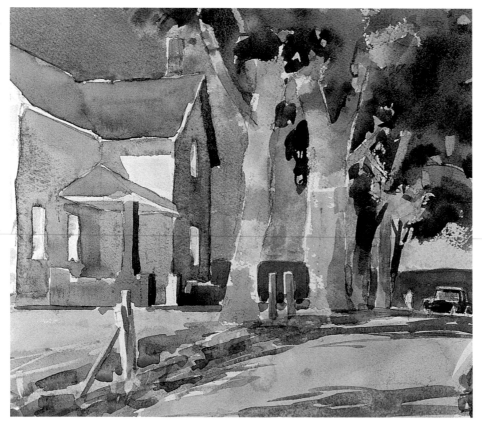

2 Using simple combinations of reds and yellows, grayed here and there with blues, paint the warm hues of the tree trunks, porch supports and so on. Add cool cast shadows to the sunlit side of the house, and lawn and across the road. The shadows across the road were not actually there, but Hill adds these as design and atmosphere elements to help the painting—part of the "editing" mentioned previously.

DETAIL The roof color is made from Permanent Rose grayed with a little blue and yellow. Darken the hills with a glaze of the original wash: Cobalt Blue and a bit of Permanent Rose.

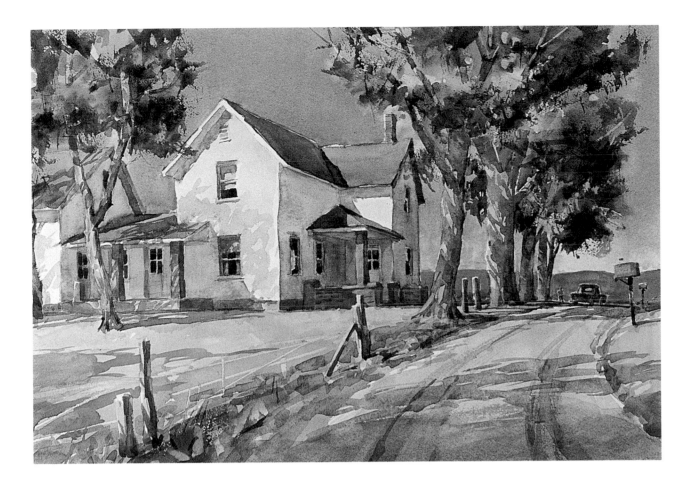

3 As the painting nears completion, add details such as windows, doors, ruts in the road (these ruts are also an "editorial" addition) and cast shadows on the roof—which, by their shape, help explain the structure of the roof. At this point, the painting is actually finished insofar as its design, color and feeling are concerned. A very few final touches are all it needs.

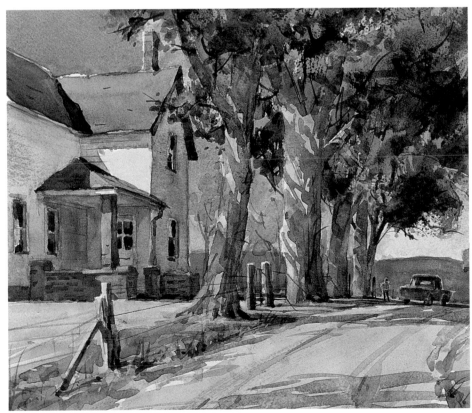

DETAIL Add darks to the tree foliage using a very rich mix of Thalo Green, toned down and warmed with Burnt Sienna.

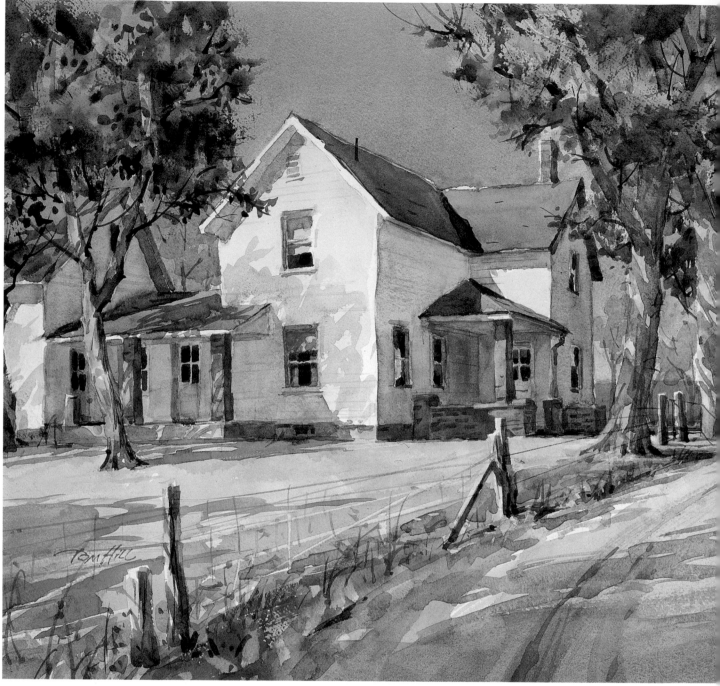

4 Add some light-value, smaller trees in back of the other trees and the house to help give the feeling of lots of space between the house and the distant hills. If you look at the photograph on page 83, you'll see a lot of large trees in back of the house, which can be edited out in favor of more visual impact for the house itself.

Finally, add small branches, fence wire and a faint indication of clapboards on the walls of the house. A little of this sort of detail goes a very long way, so don't do more than a hint of it! Most viewers enjoy having something left for them to imagine.

TOM HILL
Farmhouse on the Hill
Watercolor, 13" × 18½" (33cm × 47cm)

DETAILS OF STEP FOUR

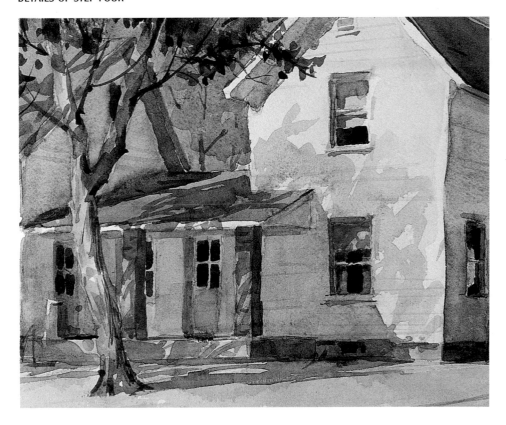

Painting a Village

TOM HILL

The local folk say "Mowzole," running the sounds together. The map of Cornwall, England, reads "Mousehole" and that's appropriate, for it is, indeed, a very small town with a *tiny* harbor, protected from the sometimes raging English Channel by a *big* seawall. According to Hill, driving along the coast of Cornwall presents one fine painting subject after another—and little Mousehole is no exception. "I was enjoying the early October weather: sunny ten minutes, fast-moving rain clouds for another ten (all the while a blustery wind whipping in from the sea) and then back to sunny again. Exciting weather and great scenery!" says Hill.

He went down to the harbor's little sand beach, intent on painting as best he could despite the wind and ever-changing weather. "I had to tie my tripod easel down with strong string attached to a heavy rock, just to keep it from blowing over," says Hill. "Occasional drops of seawater, having been blown right over the seawall and far enough to reach me, hit my back."

But to Hill it was all worth the effort and inconvenience: "It was so exhila-rating, and the painting information that was directly in front of me was certainly superior to having only sketches or photos to paint from, useful though those things are." He was able to complete the painting on location, except for a few final touch-ups that he did later that evening.

PAINTING GOAL

"I hoped to paint a watercolor that says clearly to all who see it: This is an old seacoast village, and it's a blustery and exhilarating day."

A drawing Hill made of the subject prior to painting it.

This is a view of Mousehole, taken from about where Hill stands to paint. These venerable buildings face the tiny harbor, the seawall and the ocean.

Here's another view of Mousehole, taken from the opposite side of the harbor area. You can see the beach where he paints, the large seawall and breakwater, and the English Channel beyond.

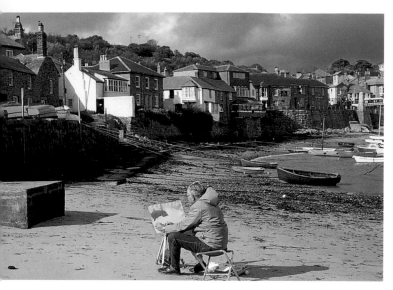

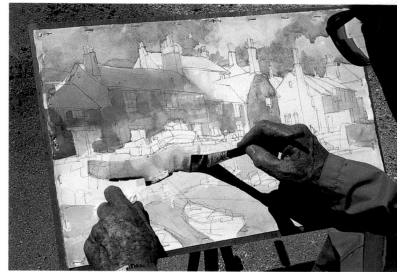

Hill painting on the beach at Mousehole.

The painting in progress, Hill adds a grayed blue-violet wash to act as a background value for the wall's rock shapes, which are added after this.

Hill uses a heavy rock from the beach, tying it to his tripod-easel with a strong string so that it hangs slightly above the sand. This keeps the rock's full weight in force and holds his watercolor board fairly steady in the wind.

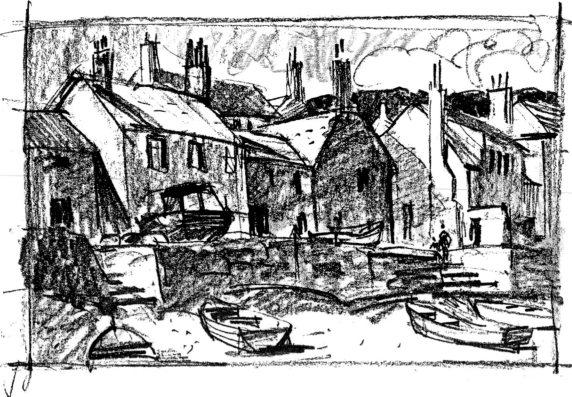

Here's a compositional design and value study (reproduced actual size) that Hill refers to as he pencils his design onto the watercolor paper.

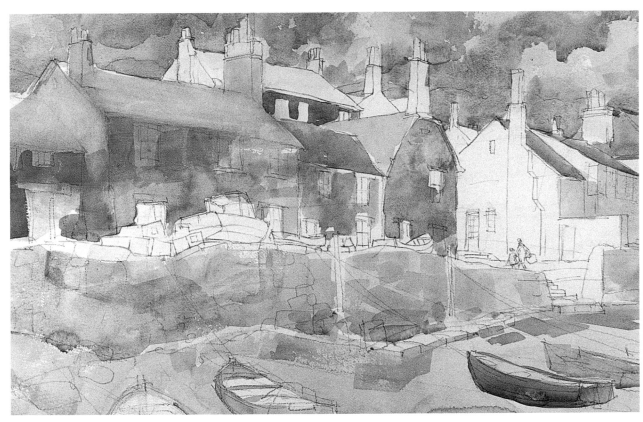

1 Because he is working nearly vertical with the wind blowing, Hill paints mostly flat patterns of watercolor wash on dry paper, the only exception being a little wet-into-wet on the sky and foreground areas. He is able to "charge" some warm and cool hues into flatly painted places before they dry, as in the faces of the buildings.

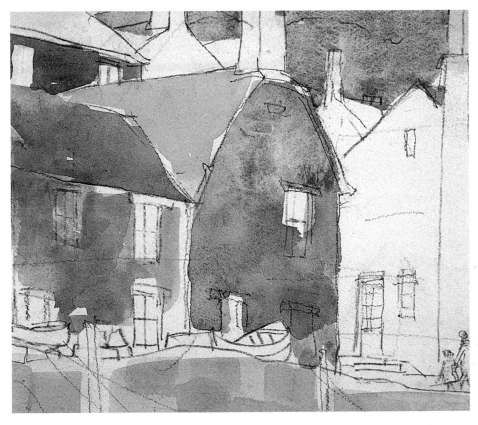

DETAIL The enlarged detail shows this warm and cool "mingling."

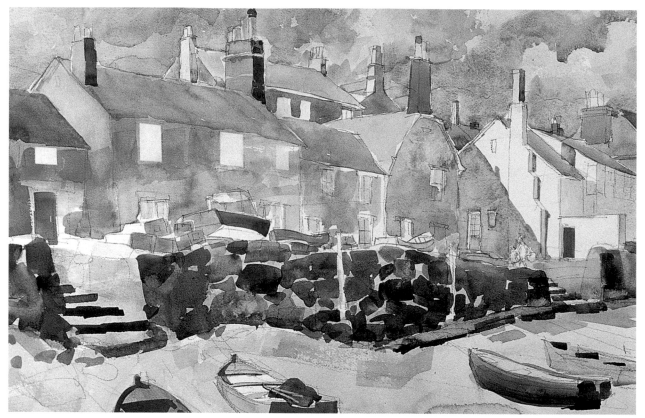

2 Using a 1-inch (25mm) flat brush, Hill paints the rock shapes on the wall by the sand. Then he paints the shadows on the white building and the boats that are pulled up on the sand. He also paints more roof shapes and indicates the stone steps.

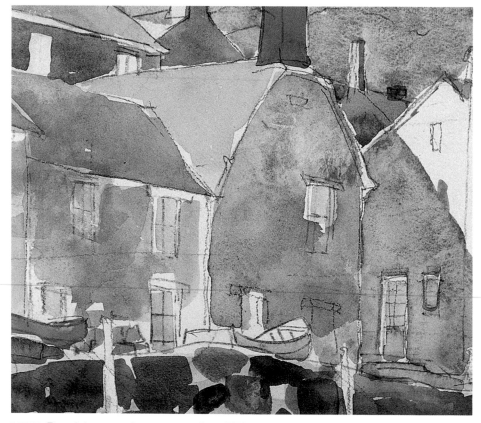

DETAIL By mixing complementary colors, Hill achieves nice darks—both warm and cool in color cast; for example, blue with orange (Burnt Sienna), reds with greens, yellows with violets and so on.

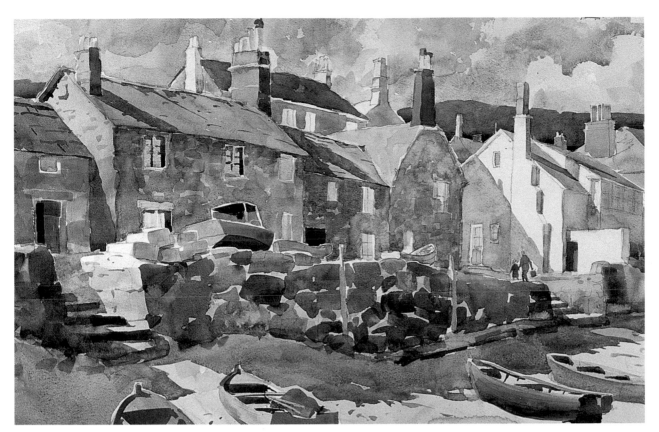

3 Hill paints the dark hills in back of the rooftops, the cast shadow on the sand in the foreground and more details and shadows on the boats and buildings.

DETAIL Hill adds flat washes to the building walls to indicate stone patterns by glazing this wash directly over the previous wash, while leaving bits of the first wash showing through.

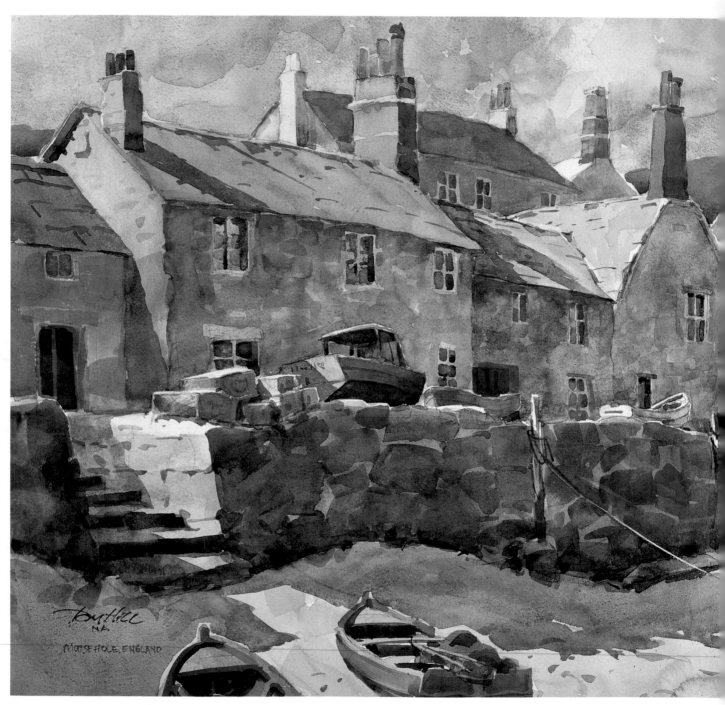

TOM HILL
Blustery Weather, Mousehole, England
Watercolor, 14" × 21" (36cm × 53cm)

4 Hill finishes the painting by adding a few final touches and details: the darks and reflected lights in the windows and doors, some refinement of the two figures, the boats and the fish traps. The three enlarged details show how some of this work is accomplished.

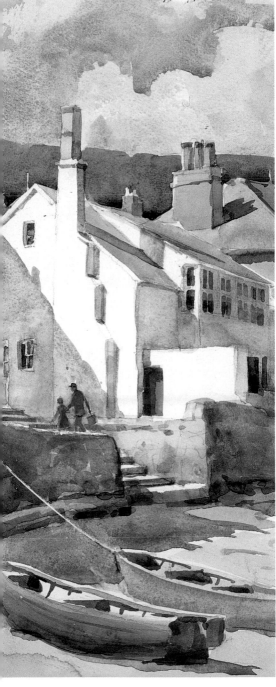

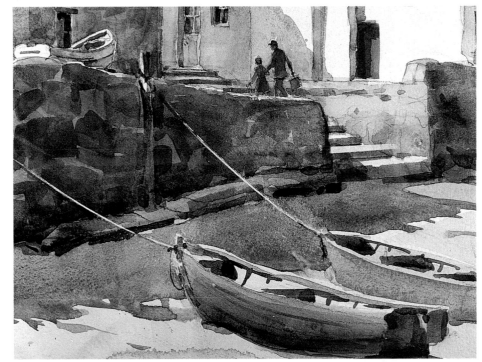

DETAILS OF FINISH

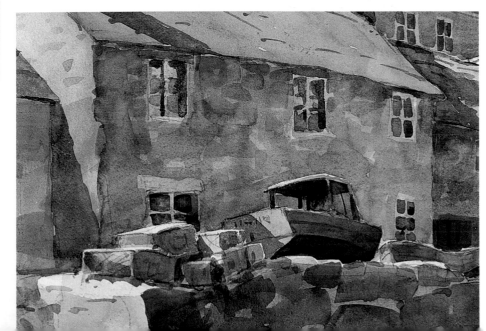

Painting a Southern Home

GEORGE KOUNTOUPIS

*G*ingerbread House depicts a typical scene in Eureka Springs, Arkansas. George Kountoupis painted in this area for years. Lately, it has become a very popular tourist spot.

This unique house offers many possibilities to save some white paper. "There is nothing as attractive as pure white paper untouched by pigment," says Kountoupis.

1 To start, carefully work out value and composition study. You may do several of these before deciding on one. Superimpose a simple grid line to assist with enlarging the drawing.

2 Enlarge the drawing on a full sheet of 300-lb. (640gsm) cold-press watercolor paper. Use masking fluid or tape on areas you wish to leave white.

3 Using a 3-inch (76mm) brush, wet down the entire area around the house. At top right, immediately charge in Alizarin Crimson and Cadmium Orange, followed by a green mixture made from Payne's Gray, Raw Sienna and a little Ultramarine Blue. The values run from light to middle light. At top left, put warm and cool greens of the same values. Next, balance some of those greens in the foreground on the lawn and bushes. The street gets a wash of Manganese Blue and Permanent Rose, with some areas left white. When these areas are dry, remove the masking tape from the roof and other areas, but keep some of the windows and trees masked off.

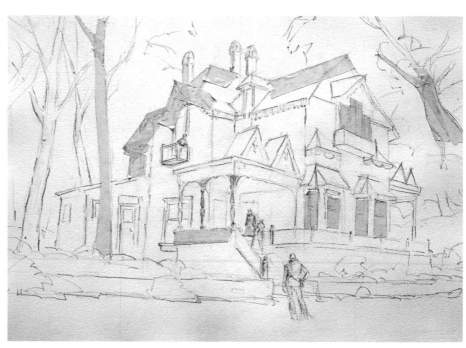

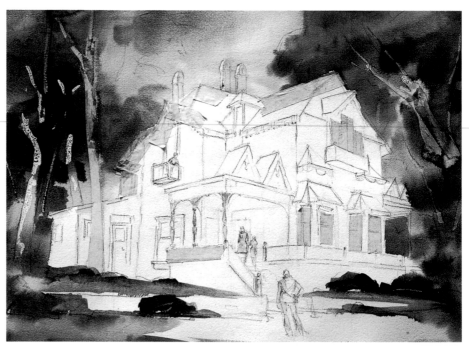

4 Lay in the shadows of the house using Cobalt Blue and Permanent Rose, adding orange at the base for reflected light. While these are drying, add darker values in the tree foliage at the top of the paper using the same colors as previously, with some Cadmium Red for accents. When everything is thoroughly dry, remove all the remaining masking fluid and tape.

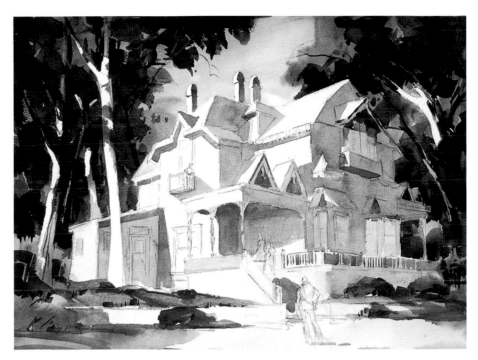

5 Now add the final details such as windows, doors, cast shadows of trees and figures. Adjust any values that are not quite right. Under the porch, show a warm, reflected light bouncing up from the floor onto the walls. To complete the painting, use a rigger brush to indicate a few twigs in the trees and bushes.

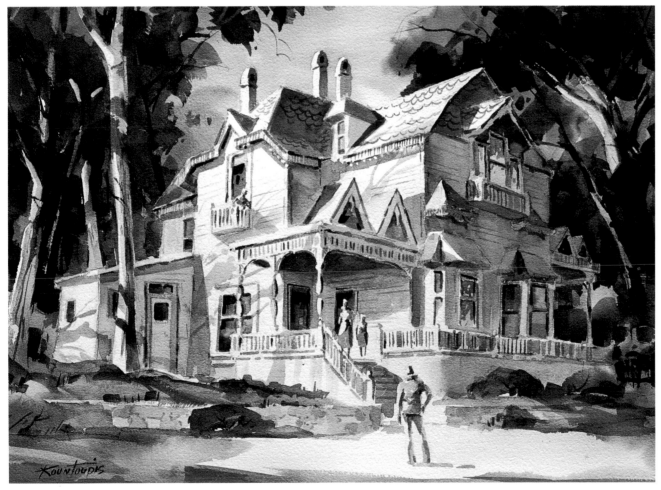

GEORGE KOUNTOUPIS
Gingerbread House
Watercolor, 22" × 30" (56cm × 76cm)

Painting an Adobe Dwelling

TONY COUCH

One of the advantages of transparent watercolor over other mediums is its fresher, sparkling spontaneity. Nothing promotes this mood of spontaneity more than the contrast between the painting's dark and midvalue washes and a bright, well-placed white shape.

1 Begin planning with a value sketch. Next, sketch the subject on a sheet of 140-lb. (300gsm) cold-press Arches paper. Wash in a nice variety of light values on the side of the building facing the viewer, since it is not in direct sunlight. Do this modeling first, so you know how dark to get with the midvalues. Leave the sunlit side as untouched white paper.

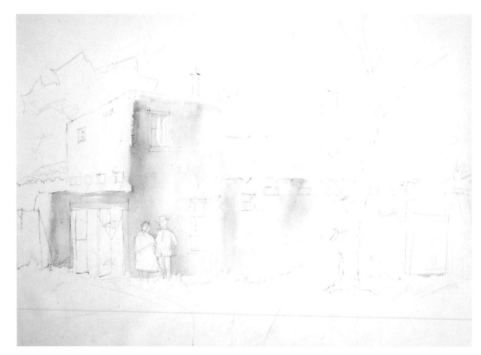

2 Add the large sky wash, cutting around the building and the small white chimney shapes. Add other colors and strengthen values in the sky. While this area is still wet, add a yellow-green mixture for the soft-edged trees in the distance.

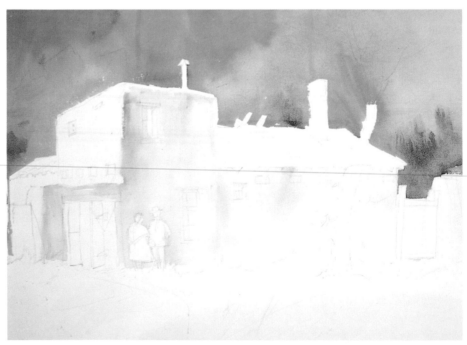

3 Surround the light adobe shape with fairly dark midvalues, and place the darkest ones in the areas touching it—the roof, trees and adjacent weeds. Be careful to make the midvalues darker than the light washes on the wall painted in step 1. Now, by contrast, the area *appears* white, even though there are some light values washed into it.

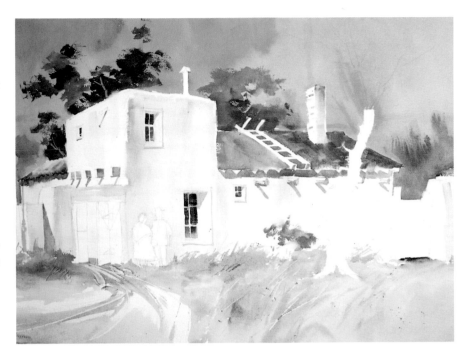

4 In this final step, simply add enough detail to make the shapes understandable and interesting. Add a few dark accents, such as the figures and the doorway at the center of interest. All parts of the building facing the direct sunlight are left as clean, untouched white shapes.

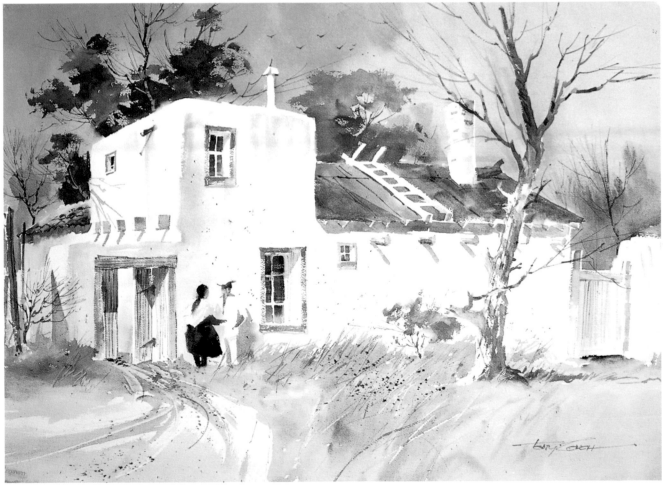

TONY COUCH
Adobe
Watercolor, 22" × 30" (56cm × 76cm)

Painting a Colonial Plantation

MICHAEL P. ROCCO

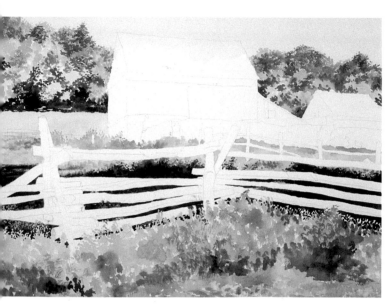

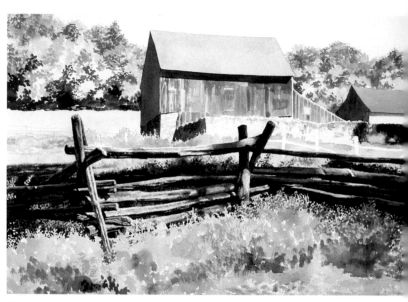

1 First paint in the sky color and, while this area is drying, put in the pale greens of the distant field. In the foreground, use various greens to start the formation of weeds and grasses. Also add light earth tones near the bottom of the composition. Proceed with the background trees, again using different tones of green to establish form, and adding the dark green shadows to establish the edge line of the field. Now apply the dark greens of the shadows behind the fence, structuring it as you go. All of this should be handled loosely.

2 Paint the sunlit wall of the small barn, and give the stone wall in front of the barns its first colors. Next, apply basic colors to the side of the large barn. Keep your brushstrokes vertical to follow the direction of the siding. Add color to the barn roofs, and paint the shadow sides of the barns, noting reflected light. Start work on the fence by putting in all the various light colors and then adding drybrushed texture for the rough-hewn character of the rails. Follow this with the shadows, further detailing the rails, giving them shape and giving direction to the cross supports. For rails in the extreme shadows, wash away some color on the edges.

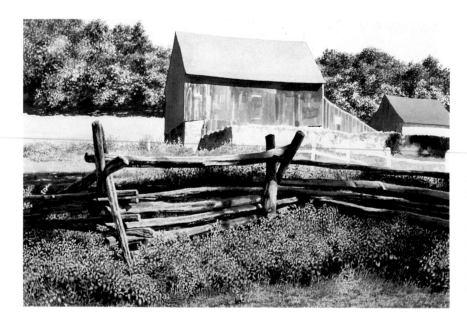

3 Paying attention to light and form, complete the background trees using a no. 2 brush in an almost Pointillism technique to gain the feeling of leaves. Further texture the distant field with deeper tones of green and other earth colors. Paint the foreground weeds by overlaying color of progressively deeper values in an overall manner to the underlayer of lighter color, shaping leaves and stems as you go. Texture the earth tones to simulate pebbles.

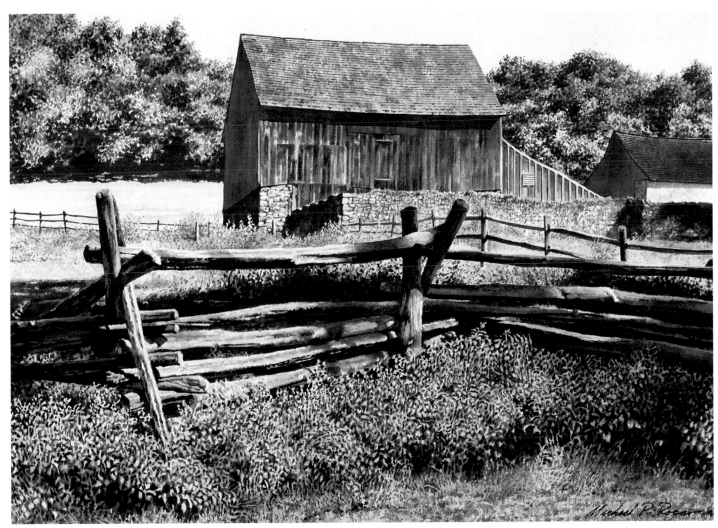

4 Now work on the roofs, adding areas of deeper color, drybrushing for texture and lines for shingles. Give the side of the small barn a feeling of stucco. With variations of color, detail the stone wall in front of the barns and add the dried vegetation that clings to it. Finish the wood siding and the stone foundation of the large barn. Paint the fine details: the fence on the right that leads the eye back to the barn, and the fence in the middleground field.

This structure is part of a re-creation of a Pennsylvania farm from the 1700s, where visitors can witness the working activities of that time. Many of the buildings have been standing since the eighteenth century, but the barn is a recent reconstruction using traditional tools and methods.

MICHAEL P. ROCCO
Colonial Plantation
Watercolor, 14"×21" (36cm×53cm)

COLORS

- Lemon Yellow
- Yellow Ochre
- Olive Green
- Hooker's Green Deep
- Payne's Gray
- Burnt Sienna
- Alizarin Crimson
- Neutral Tint
- Warm Sepia
- Raw Umber

Painting a Street Scene in Spain

MICHAEL P. ROCCO

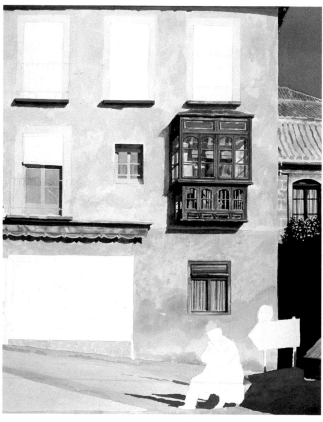

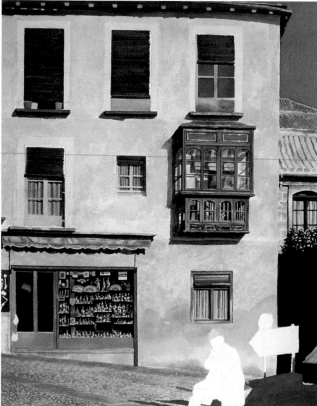

1 The pale Yellow Ochre of the building is the first color to paint, leaving all the windows clear. This is followed by the pale gray of the cement foundation. To establish values and color relationships, paint in the sky, again leaving some areas clear.

2 After painting basic light colors of the cobbled street and the slate walk, add some drybrushed texture to the large wall with a deeper tone. Paint the building at the right almost to completion. The lower windows of the main building, the French doors of the building at right and details such as the awning and shadows should be added at this point to help you feel depth in the painting.

3 Now put in all the major colors of the windows, roll-up shutters and wood doors. To simplify painting the display, work on one shelf at a time, completing all statuettes with shadow, form and color, and then fill in the dark background.

4 Now start working on the figure. First, paint the general color, the flesh tones and light values of the clothing, and then paint intermediate tones to establish form in the head and folds in the coat and trousers. Finally, add the shadows, blending for soft edges.

Paint more texture in the roof tiles, and loosely delineate them. Use a small pointed brush to paint in the horizontal lines of the roll-up shutters. Finally, paint all the shadows cast by the railings before adding the railings over them.

MICHAEL P. ROCCO
Villatobas, Spain
Watercolor, 21" × 14" (53cm × 36cm)

COLORS

- Yellow Ochre
- Raw Umber
- Chrome Orange
- Burnt Sienna
- Cerulean Blue
- Olive Green
- Hooker's Green Deep
- Alizarin Crimson
- Lemon Yellow
- Payne's Gray
- Neutral Tint
- Warm Sepia

Painting Houses in Winter

MICHAEL NEVIN

On the following pages Michael Nevin uses examples from his painting *Backyards, Winter* to show the basic methods he uses for most of his paintings.

TIP: SEAL YOUR DRAWING

After perfecting your detailed pencil drawing on the gessoed panel, seal it by brushing matte medium, full strength, directly over the completed drawing. This fixes the drawing so that even vigorous brushwork applied over it doesn't smudge or erase the lines; the linear foundation remains intact. This is particularly important in scenes that involve complicated perspective and exact proportions.

1 DRAW, SEAL AND TONE

After sealing the graphite drawing with acrylic matte medium, apply a light wash of Cerulean Blue to the whole surface. Toning the surface (in this case, with Cerulean Blue) serves both to eliminate white, replacing it with a middle value, and to establish the prevailing warmth or coolness of the painting to follow. Sometimes Nevin uses a contrasting color, but in this case he sets the tone for the prevailing blueness of the scene. Lay in some of the other colors, using Titanium White—a cool white—as the base for the buildings. Make brushstrokes for the background trees in a radiating fashion to suggest the patterns and shapes of the tree masses.

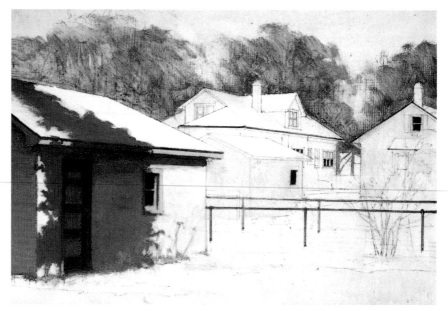

2 DILUTE WITH WATER

For the large shadow across the building on the left, mix Ultramarine Blue with Phthalo Blue and Titanium White cut with about 25 percent water. Diluting the mix suggests the subtlety of the shadow. Full strength would make it too opaque and heavy.

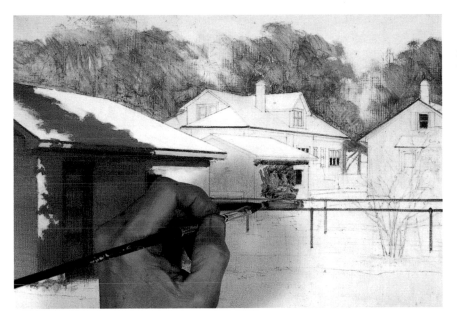

3 PAINTING WITH ACRYLIC WASHES

Apply a wash of 25 percent water, Ultramarine Blue and Burnt Sienna to the wall of the garage in the center, representing shadow. As it is farther back in space, its color is less intense than the shadow falling over the garage at the left. By painting with washes, you can build up color slowly, giving depth and texture to the painting.

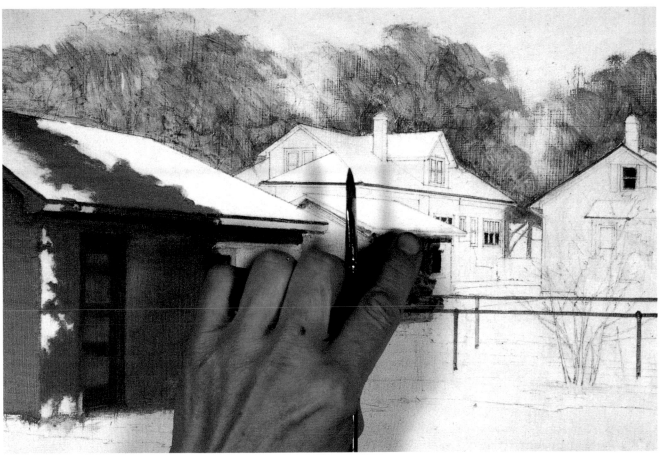

4 FINGER PAINTING

Nevin frequently uses his fingers to blend or soften a wet area. Here, he found that the paint he had just applied to the garage was not quite what he wanted. It's common to modulate a color once it's laid in, and your fingers can be useful tools to use with a rapidly drying medium.

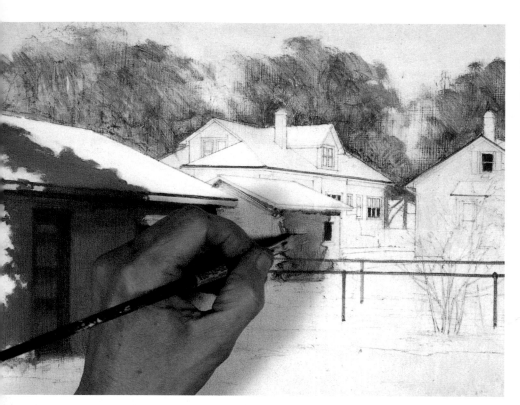

5 WET-INTO-WET

The tone is still too dark and overly prominent, so Nevin adds an application of Unbleached Titanium at almost full strength, working wet-into-wet.

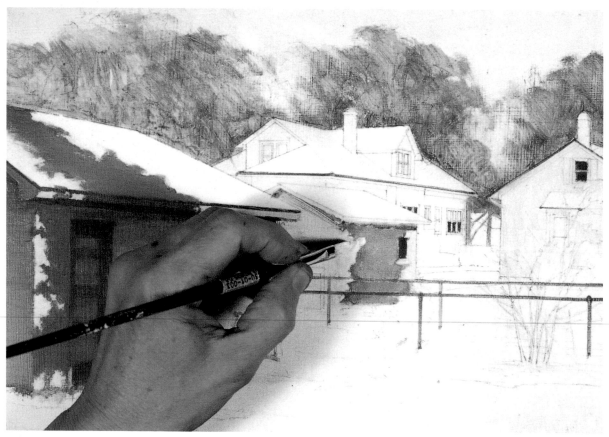

6 FULL-STRENGTH WHITE

Paint the lighted portions of the wall, using Unbleached Titanium and Titanium White full strength. Drybrush the edge as it meets the greenish shadow, feathering the line to make it softer, in contrast to the sharper edge at the roof line.

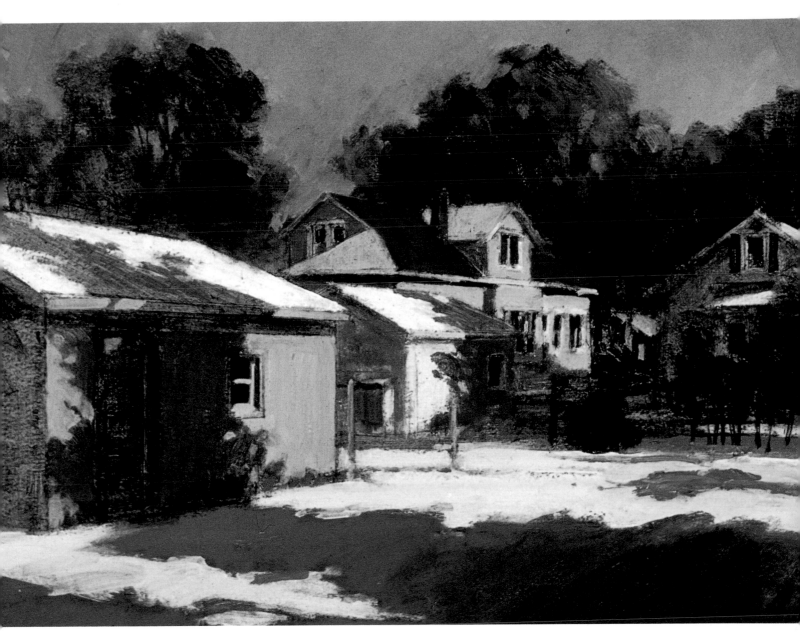

7 THE FINAL TOUCHES

To complete the painting, paint the houses in the middle distance in a way similar to the garage discussed previously. Paint the large shadow in the foreground with a dilution of 15 percent water. This allows you to draw the brushstrokes directionally over the plane of the snowy yard, creating a directional force leading into the painting. The sky, Cerulean Blue and Titanium White full strength, is joined to the trees with drybrush to soften the effect. The drama of strong light and shadow transforms what might otherwise be a very ordinary scene.

MICHAEL NEVIN
Backyards, Winter
Acrylic, 9¾" × 14" (25cm × 36cm)

TIP: USE WASHES WITH ACRYLICS

Make a wash by adding water to the paint in varying amounts. The more water, the thinner and more transparent the wash. You may wipe or blot a wash tone if it seems too strong; you may add more washes over the initial one, once it is dry, to darken the color.

Painting an Urban Scene

MICHAEL NEVIN

1 MAKE A DETAILED DRAWING
Begin the painting by making a detailed drawing directly on the gessoed surface. This design is a composite of several reference photos, with the car at the left added to balance the composition. The signs are an integral part of the picture, and they need to be done right—a crudely done sequence of letters mars what might otherwise be a very skillful piece. The "Fannie May" lettering was copied from the lid of a candy box.

After completing the drawing, seal it with matte medium to keep it intact. After it dries, lay a light wash of one part Vivid Red Orange and two parts Raw Sienna over the entire surface, giving a vibrant undertone for the portions of the picture in sunlight. (It's easier to subsequently darken than to lighten.)

COLOR PALETTE

- Titanium White
- Unbleached Titanium
- Vivid Red Orange
- Cadmium Red Light
- Hooker's Green
- Phthalo Blue
- Yellow Oxide
- Raw Sienna
- Burnt Sienna
- Raw Umber
- Burnt Umber
- Red Oxide

BRUSHES

- No. 2 Rathbone filbert
- No. 3 Rathbone filbert
- No. 4 London filbert
- No. 16 Wilton bright (for washes)

2 ESTABLISH LARGE PATTERNS
Using light washes, establish the large patterns in the composition. Combine Cadmium Red Light and Red Oxide with 20 percent water for good flow to lay in the signs. Render "Service Optical" in Unbleached Titanium; bleed the red wash around the edges of the letters. Delineate "Footwear" first with Titanium White and Cadmium Red Light. Add the surrounding dark, and then wash the whole word with Cadmium Red Light to create the effect of neon light.

3 WORK ON LIGHT PATTERNS

For the top row of windows, dilute Hooker's Green about 50 percent to indicate blinds, making the spaces between darker. A suggestion of overhead interior lights is seen between the blinds. For the raised letters, paint the shadows first with a diluted mix of Phthalo Blue and Burnt Umber, which is then washed with Raw Sienna to warm the tone slightly. Then paint the letters.

The top third of the painting is complete. Render the mortar in Burnt Sienna cut with 15 percent water. Paint the bricks with Unbleached Titanium and a small amount of Vivid Red Orange used full strength to maximize the effect of sunlight.

The stone band just below the brick walls and windows is initially Raw Umber, a hue with a high degree of transparency. Make a second application, adding Unbleached Titanium; allow the initial coat to define the cleft's pattern.

Darken the street with a wash of Phthalo Blue and Burnt Umber. Use Unbleached Titanium and Phthalo Blue for the light patterns cast from the el tracks overhead. The street that is in shadow will be painted around these light pools or bands.

Complete the "Service Optical" sign using Unbleached Titanium and Raw Sienna plus Raw Umber, full strength, allowing the red-orange bleeds around them to remain.

4 WORK TOWARD COMPLETION

Now concentrate on the left half of the picture, bringing the car to completion in order to get a feel for how the areas in sunlight will work with those in deep shadows. Develop the "Service Optical" windows using Phthalo Blue and Burnt Umber cut with 20 percent water to give the feeling of transparency and reveal the forms inside the store. Use the same mix to darken the street. Use the largest brush with sweeping, horizontal strokes to underscore the feel of the street as a plane. Several applications are necessary to bring the pavement to an *almost* opaque state—"almost" because you will want to retain a slight amount of the undertone.

TIP: DRAW

Draw freehand with a 3H pencil and, occasionally, a ruler. Drawing freehand allows you to familiarize yourself with the subject and to work out problems of perspective and proportion. "Drawing is the foundation of my work," says Nevin, "and when I do complicated urban scenes, I often spend as much time on the drawing as I do on the painting."

5 THE FINAL TOUCHES

Use Titanium White full strength to complete the "Fannie May" sign. Use Unbleached Titanium for the awning stripes and to lighten the pavement toward the curb. Intensify the bands of light on the pavement with Unbleached Titanium combined with Vivid Red Orange and Raw Sienna.

STREETLAMP

Render the streetlamp above the truck in thin applications of Unbleached Titanium and Raw Umber. Add Phthalo Blue for the darkest accents. By painting "thin," you allow the warm, yellowish undertone to resonate with what you add over it, keeping the color alive and vibrant.

TRUCK

Paint the truck in Burnt Umber darkened with Phthalo Blue, applied full strength. Where the contour changes into light, cut the mix with 20 percent water. Render the patterns of light on the truck by applying a Vivid Red Orange wash, and then painting over it with a combination of Titanium White and Yellow Oxide. Allow the red-orange to show at the edges for a more vibrant effect and to act as a transition to the dark areas. The reflection in the vertical plane is rubbed back, and then washed with Cadmium Red Light to reflect the sign and the storefront.

After making a few final adjustments, seal the painting with acrylic matte varnish.

MICHAEL NEVIN
Service Optical
Acrylic, 14" × 20" (36cm × 51cm)

More Urban Scenes

Although they are not always the primary focus, most of Michael Nevin's work contains architectural elements. They suggest a human presence even when no figure is actually seen. As forms, they are often complex and invariably interesting foils for light and shadow, a major element in his paintings.

TIP: WET SURFACE

A "wet appearance," such as that of a rainy street, is achieved in two steps. First, apply the paint wet, as in a wash, resulting in a soft-edged transparency that itself suggests "wet." Then you can paint in reflections on roofs, streets and sidewalks, keeping the paint semitransparent and the edges soft, to complete the effect.

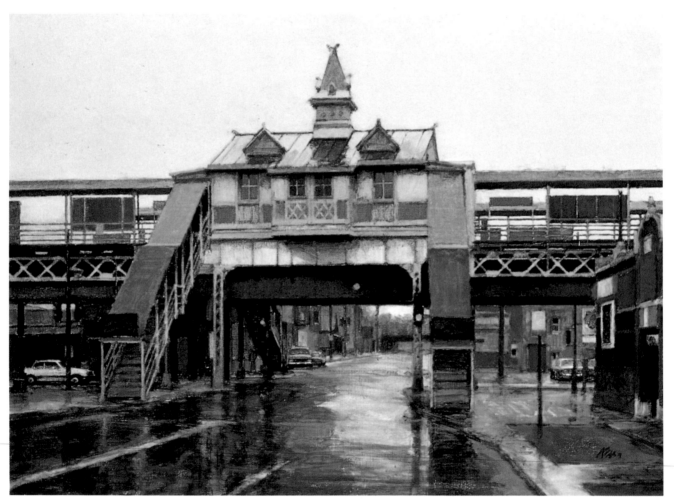

MICHAEL NEVIN
Lake Ryan Train at Ashland Station
Acrylic, 13½" × 21¾" (34cm × 55cm)

TIP: OPAQUE APPLICATIONS

Opaque applications are useful in creating high color intensities, a feeling of solidity in forms (where desired) and highlights of accents. *Opaque* means paint of sufficient density to completely cover the paint layers under it. For opaque areas, use the paint at full strength without the addition of water.

TIP: SHINING CHROME

For the effect of shining metal, use Titanium White straight from the tube. Its brilliance, combined with its coolness, reads as chrome.

MICHAEL NEVIN
Federal Street, Chicago
Acrylic, 14″ × 20″ (36cm × 51cm)

MICHAEL NEVIN
Lunch at Otto Moser
Acrylic, 14″ × 18½″
(36cm × 47cm)

DEMONSTRATIONS IN WATERCOLOR, ACRYLIC AND OILS 115

Suburban Scenes

MICHAEL NEVIN
Backyard, Late
Afternoon
Acrylic, 12" × 8¾"
(30cm × 22cm)

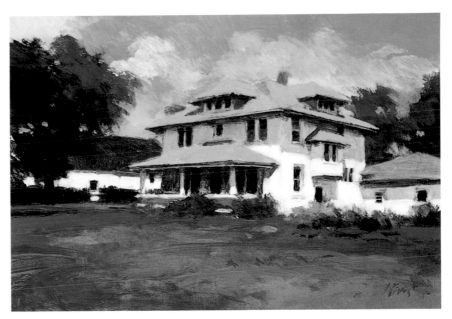

MICHAEL NEVIN
Farmhouse, Fulton County, Ohio, #2
Acrylic, 7" × 9¾" (18cm × 25cm)

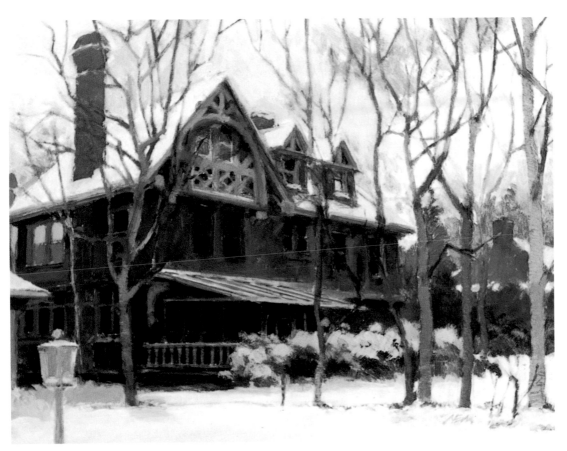

MICHAEL NEVIN
House After a Snow
Acrylic, 9¾" × 14" (25cm × 36cm)

Handling Detail in a Backlit Subject

PAUL STRISIK

1 WASHING IN THE PERVADING TONE
A dull red-violet tone pervades the subject, so he lays in the drawing with a wash of Ultramarine and Cadmium Red Medium.

The Artist on Location
Paul Strisik's vantage point for this painting is on the bridge spanning the Yonne River in the French village of Auxerre. He is looking almost directly into the late sun, creating a strong backlit silhouette.

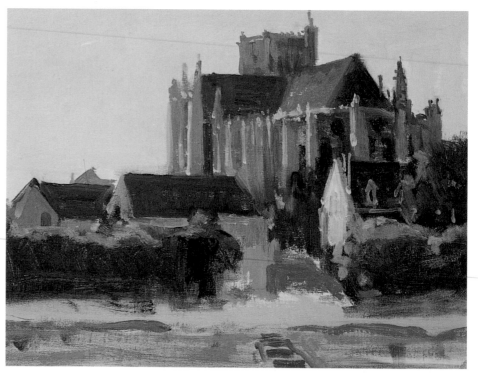

2 CREATING THE LIGHT EFFECT
Since Strisik is looking into the light, he paints the sky with Light Yellow Ochre, a hint of Phthalo Blue and white. He starts to model the buildings with a yellowish tone and variations of his original red-violet. His aim is not to get too caught up in the drawing and all the details, but to create the light effect that attracted him to this subject. If the light had come from the front, the details would have been overwhelming, and the striking silhouette would have been lost.

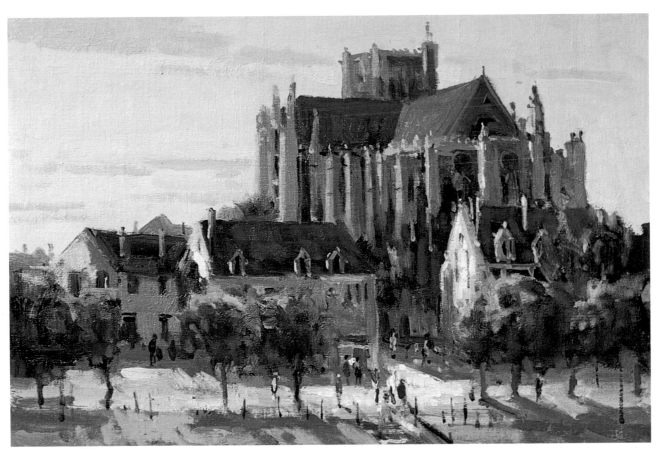

3 TELLING THE POETIC TRUTH

Strisik edits the tree pattern for variations and opens the center portion to include some human activity. The trees are dark green with a strong top light. The flat plane of the sidewalk gets full sun: It is consequently very light, and even lighter at the center of interest. He makes necessary adjustments to value and shapes. He has not slavishly followed the photograph, but picked out only those parts of the scene needed for the effect he wants. This results in a poetic truth rather than a photographic truth.

PAUL STRISIK
Saint Etienne, Auxerre, France
Oils, 10″×14″ (25cm×36cm)

Making Shadows Glow With Reflected Light

PAUL STRISIK

1 PRELIMINARY DRAWING AND WASH IN
This beautiful Venetian church has inspired countless painters throughout the ages. Strisik has painted it from many angles and has always enjoyed the challenge.

Due to the subject's complexity, begin with a careful charcoal drawing. Then go over the drawing with a warm gray and wash in some of the general colors, including the sky.

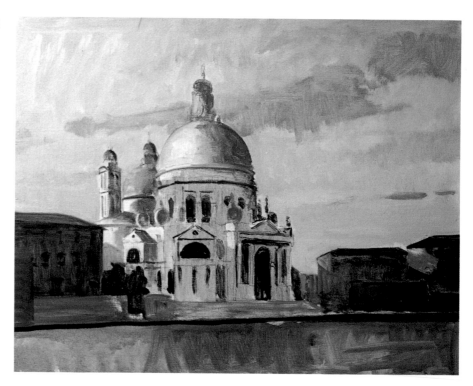

2 PLANNING LUMINOUS SHADOWS
Change the sky to show some blue and the direction of the elongated cloud. Strisik also starts putting more paint on the church and buildings, since he is now more certain of the general composition. Most of the church is in shadow so, to avoid an uninteresting subject, plan to make the shadows luminous and full of reflected light. For now, use a gray-blue of medium value. Compare this value to touches of pure white so you can make the shadow as light as possible and still leave room for good contrast with the sunlit portions.

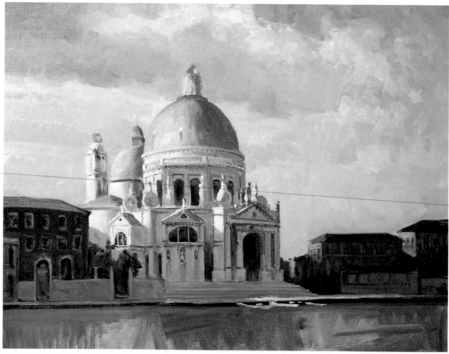

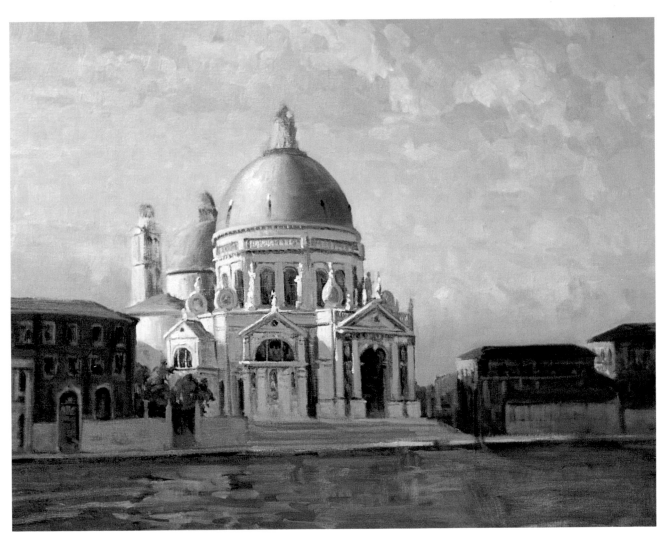

3 REFINING THE COLOR OF THE SKY

At this stage paint over the entire canvas, refining shapes, color and values. The clouds are warm white, but grayed somewhat to keep their place; the horizon clouds are a warm gray-violet, and the sunlit clouds above the horizon are warm with orange. The sky in this painting speaks of a warm, late-in-the-day atmospheric effect.

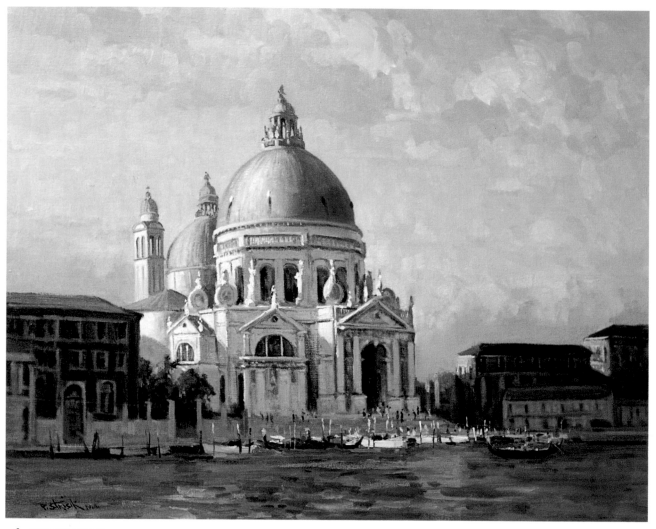

4 ADDING DETAIL

Add boats and water. Put in details and accents with careful judgment.

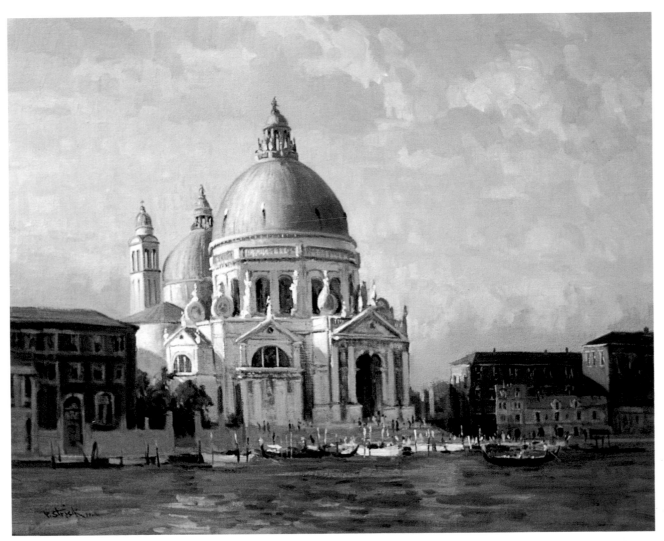

5 WARMING TOUCHES
In the final stage, go over all the lights, including the clouds, warming them a bit. To achieve the feeling of light and luminosity, work yellowish tones, representing reflected light, into the shadow portions of the church.

PAUL STRISIK
Santa Maria Della Salute, Venice
Oils, 24" × 30" (61cm × 76cm)

Finding an Original Viewpoint

PAUL STRISIK

PHOTO
Being fond of bridges, Strisik can not resist this view of the Louvre. With permission to paint from a dock, he sets up his 10″ × 14″ (25cm × 36cm) box and tripod. The resulting field sketch is used later in his studio as the basis for the finished painting.

1 STARTING WITH A SUGGESTION OF THE SUBJECTS

After he started, the sun came out and gave him a welcome opportunity for a more pleasing effect. Strisik draws in the subject with a brush and Raw Umber, freely suggesting the anatomy of the building and the windows.

2 DEFINING LIGHT AND SHADOW

Here he starts with color, defining the light and shadow portions of the Louvre. He plans to use Yellow Ochre with white as basis for the lights and a gray-violet mix of Ultramarine and Cadmium Red Light and white for the shadows. The bridge, Pont Royal, is in half light and appears quite warm. At this point, he gives a thin wash of color to the water.

3 WORKING THE WHOLE

He continues working on all parts of the painting, bringing out details but being careful to keep them only suggestions, without sharp edges. He applies, in broken color, a thin hint of light blue on the shadow side of the bridge to suggest sky influence. Since the river is flowing, the reflections are not as mirrorlike as they would be on calm water.

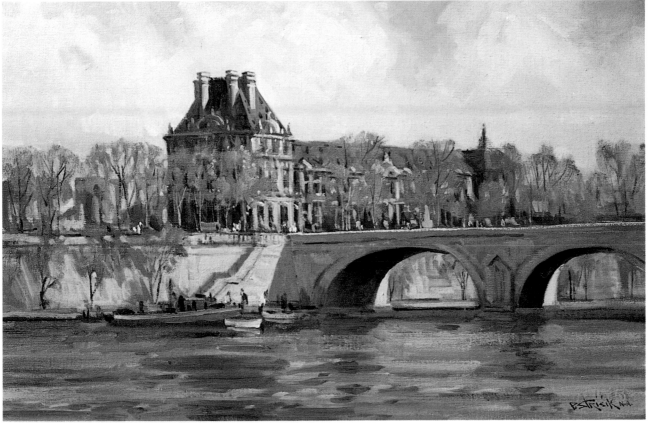

4 ADDING DETAIL

Strisik adds the autumn trees and some activity, such as boats and figures on the bridge. The addition of the lacy trees softens the hard lines of the building. These are scumbled in lightly, with trunks and branches merely suggested. He considers the painting complete at this point; however, the sky troubles him.

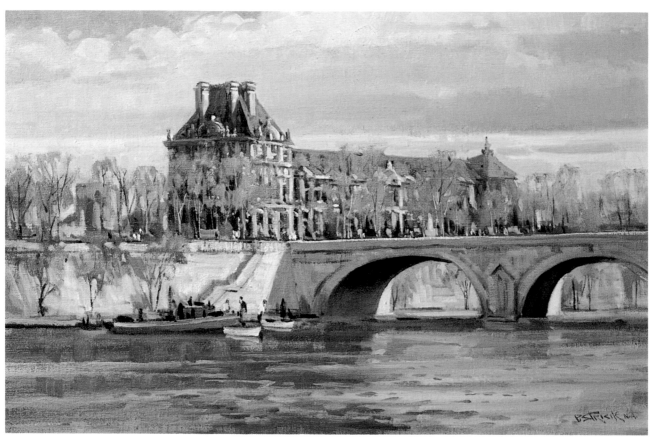

5 PERFECTING THE SKY

He decides that a different sky is needed to complement the subject. After several tries, he paints this one. This additional effort presents the opportunity to go over the shapes and values, unifying the effect of a pleasant afternoon in Paris.

PAUL STRISIK
The Louvre, Paris
Oils, 16"×24" (41cm×61cm)